Collins
PAINTING
WORKSHOP

Pastels

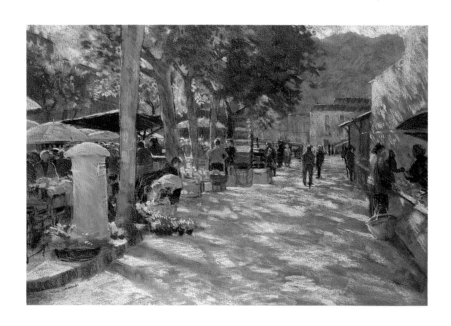

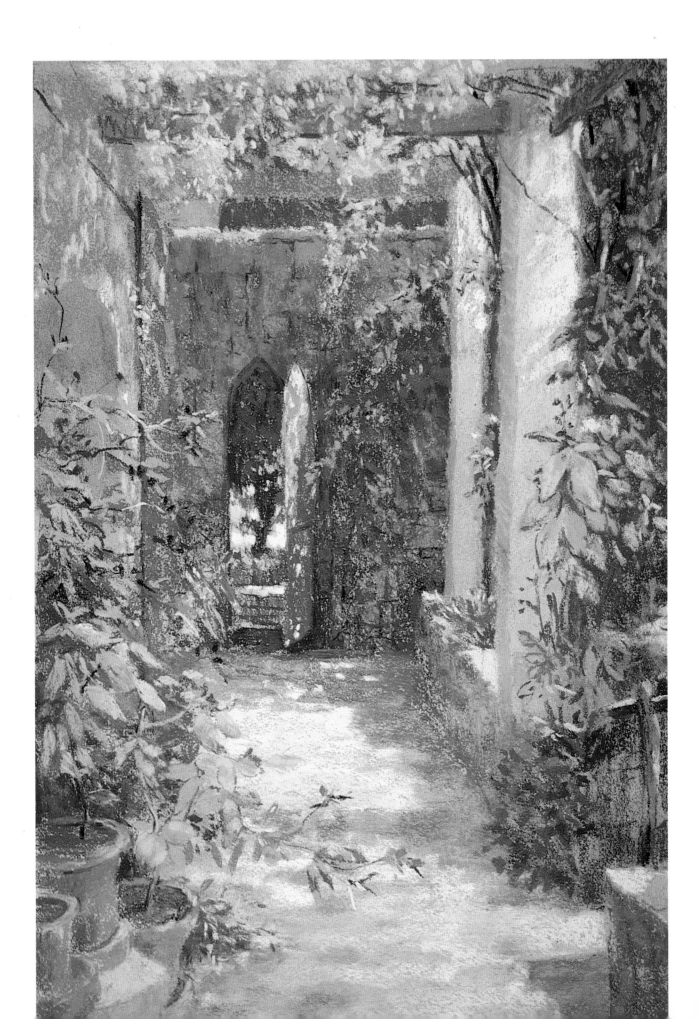

Pastels

JACKIE SIMMONDS

ABOUT THE AUTHOR

Jackie Simmonds started painting in her thirties, through part-time adult education classes, which led her to a full-time four-year course at Harrow School of Art. She is now a well-known and successful pastel painter, who in 1985 was a Pastel Society award winner. In 1992 she won the prestigious Chevron Art in Nature prize.

Her work is exhibited regularly by the Pastel Society, The Linda Blackstone Gallery in London, and other galleries throughout the UK and USA. Prints of her popular pastels have sold world-wide. An excellent teacher and communicator, Jackie Simmonds often writes for *The Artist* magazine, as well as running extremely popular and successful workshops and painting holidays. She is also author of *Collins Learn to Paint Gardens in Pastel* and *Collins You Can Sketch*.

ACKNOWLEDGEMENTS

My thanks to all the artists whose work appears in this book, and all the kind people who have loaned me transparencies or allowed me access to paintings for photography, including Chevron UK Ltd, The Linda Blackstone Gallery, and Art Marketing Ltd.

Also, I would like to thank both Sally Bulgin, of *The Artist* magazine, and Charmian Edgerton for their help and encouragement; and special thanks are due to my family and friends for their patience through my teeth-gnashing periods! Thanks to Patsy North for her editorial help; and finally, I am most grateful to Cathy Gosling, Caroline Churton and Caroline Hill at HarperCollins for their faith in me, their support and their unfailing good humour – I could not have had a nicer team to work with.

All paintings are chalk pastel on paper
unless otherwise stated. Any with titles only and no artist
specified are by Jackie Simmonds.

First published in hardback in 1994 by
Collins, an imprint of
HarperCollins*Publishers*
77-85 Fulham Palace Road
Hammersmith
London W6 8JB

The Collins website address is www.collins.co.uk

Collins is a registered trademark of HarperCollins*Publishers* Ltd

First published in paperback in 1997
This new paperback edition published in 2003

03 05 07 09 08 06 04
3 5 7 9 10 8 6 4 2

© Jackie Simmonds, 1994

Editor: Patsy North
Art Editor: Caroline Hill
Photographer: Ed Barber

ISBN 0 00 714257 9

Colour origination in Singapore, by Colourscan
Printed and bound by Printing Express Ltd, Hong Kong

PAGE 1:
Jackie Simmonds,
Pollença Market,
Majorca,
45 x 60 cm
(17¾ x 23½ in)

PAGE 2:
Jackie Simmonds,
Secret Doorway,
50 x 34 cm
(19¾ x 13½ in)

CONTENTS

ABOUT THIS BOOK

The aim of this book is to encourage you to learn by doing, just as you would in a practical painting workshop led by a tutor. Along with instructional teaching and general guidelines in the text, you will find practical exercises and projects for you to do, designed to help you to develop as an artist. As you practise and become more visually receptive and perceptive about the world around you, your own ideas, and personal style, will begin to emerge.

Most of the chapters contain one main project and, in some cases, a number of exercises. If you carry out all of these before moving on, they will effectively help you to understand and practise the teaching.

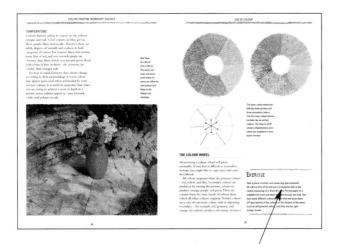

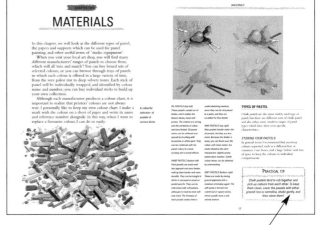

EXERCISES

These are designed to complement the teaching contained in each chapter. Some of the exercises are quite short and should not take too long to do; others may require a little more time. Their aim is to get you painting and thinking for yourself.

PRACTICAL TIPS

Throughout the book you'll also come across practical tips. These highlight some useful hints about working methods and provide a few solutions to everyday painting problems.

SELF-ASSESSMENTS

At the end of each project, you'll find a number of self-assessment questions relating to the work you have just completed; these are intended to draw your attention to particular aspects of your painting, in the same way that a professional tutor might help you to assess your work in a practical workshop.

PROJECTS

The projects, of varying degrees of difficulty, concentrate on more specific aspects of painting, with a view to sparking off ideas which you can then try to interpret in your own way.

You should take your time with the projects and be prepared to reread relevant sections of the text as often as you need to enable you to tackle them successfully. After all, there are no short cuts to learning to paint well!

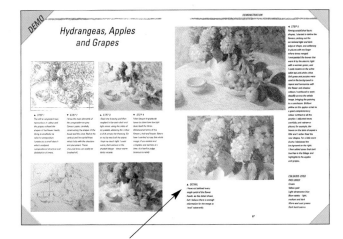

DEMONSTRATIONS

Because you can learn a great deal by watching professionals at work, several demonstrations by the author are included in the book. These show how a painting is developed from the initial drawing to the finished work, and you are taken step-by-step through each stage so that you will understand what techniques are used and

how particular effects are created. Details from the finished paintings are included to highlight specific areas of interest.

IDEAS & INSPIRATION

The paintings in the book, by the author and other well-known contemporary artists, cover a wide range of different subject matter. Some of these paintings are meant to complement and clarify points explained in the text, but others are included to show how style and

technique vary from one artist to another, emphasizing the importance of being original in your creative work. They can help you to extend your attitudes and horizons – and fire your enthusiasm. They are there for you to enjoy!

THE MEDIUM OF PASTELS

When I was asked to write *Pastels Workshop*, I was initially delighted. I thought it would be marvellous to share my enthusiasm for a medium which has given me so much pleasure. Subsequently, terror set in. How on earth could I, a perpetual student, be so arrogant as to imagine I could tackle such a task! Well, enthusiasm prevailed, as it has done ever since I first fell in love with pastels. I have no doubt that you, too, are an enthusiast. The fact that you have bought this book tells me that you are committed to the fascinating, absorbing, frustrating business of trying to be a painter. Whether you are a beginner, or a more experienced painter keen to explore pastel as an alternative, I sincerely hope that there will be something of interest here for you.

When most people buy books of this kind, they very seldom read them from cover to cover. The usual approach is to thumb through, looking at the paintings, perhaps reading a section which seems interesting. I hope that this time you might delve a little deeper. In *Pastels Workshop* I have tried to demonstrate the beauty and versatility of pastels. However, because I feel strongly that technique is only a means to an end, I have also included a great deal of information about the thinking part of painting – how to recognize, understand and utilize the elements of design, which will serve to strengthen your ability to produce individual and expressive works of art of your own.

The teaching in the book is based on my personal approach and methods. However, I do not want to promote the idea that mine is the best or the only way to work, and with this in mind, I have included many fine examples of pastel paintings from a variety of artists, each of which reflects an original, personal response to the subject. I feel privileged to be in such good company!

My aim in this book is to provide information, encourage experimentation and lead you to a point from which you can step out confidently on your own. Learning to paint is an exciting journey of exploration and discovery. I hope you thoroughly enjoy this part of your journey – the opportunity to discover the pleasure of pastel painting.

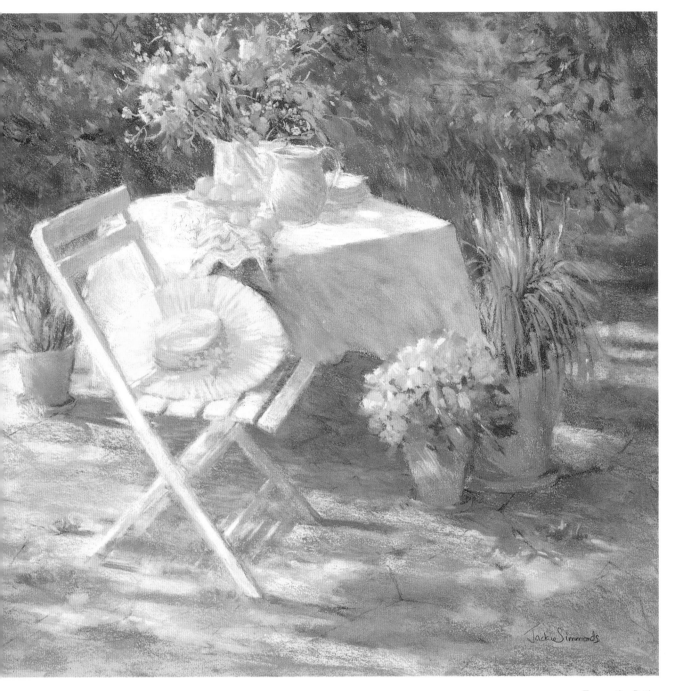

Tea on the Patio,
45 x 60 cm
(17¾ x 23½ in)

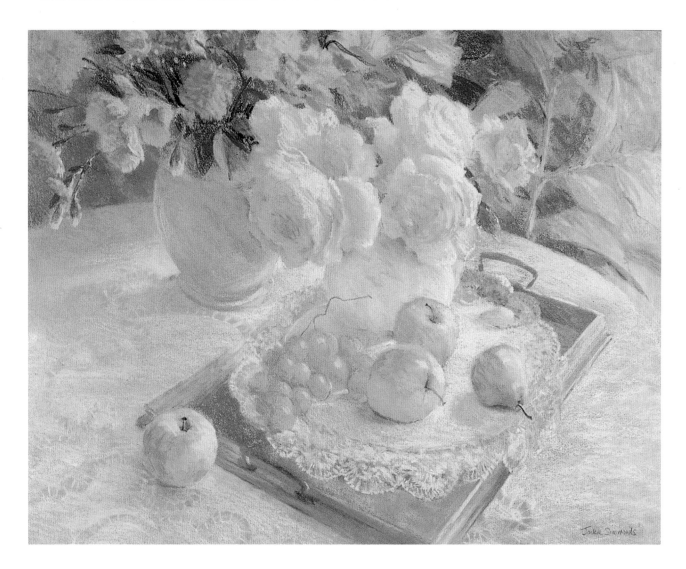

WHY CHOOSE PASTELS?

Peace,
45 x 60 cm
(17¾ x 23½ in)

I have found pastel to be an almost magical
medium. The lightest of strokes with a pastel stick,
breathed across the surface of my paper, gives me
immediate, vibrant colour, sparkling with reflected
light. Pastel is both a drawing and a painting
medium, and delightfully, has most of the qualities
of each. When you begin exploring these, you will
find that the advantages of using pastels are many
and varied.

• You do not have to 'stretch' paper or prepare
 canvases – just clip or tape your paper support
 to a drawing board and you are ready to start.

• You do not have to mix colours – you simply
 choose the colour and tint you want, and apply
 it directly to the paper.

- You do not have to wait for colours to dry, and change irritatingly as they do so! You can work continuously, or leave your painting secure in the knowledge that when you return to it, it will be exactly as you left it. Oil paints frequently 'sink' into the canvas and dull in colour, and watercolours lighten as they dry.

- Because pastels are opaque, you can overpaint successfully, and mistakes can be rectified or worked over, leaving little or no trace.

- You do not have to varnish your work to bring out the true colours.

- You can work quickly and spontaneously with pastels, or, if you prefer, they are also perfect for more considered, detailed work.

- Pastels are economical to use, easy to store, never dry out and are readily portable!

The Ginger Jar,
48 x 67.5 cm
(19 x 26½ in)

MATERIALS

In this chapter, we will look at the different types of pastel, the papers and supports which can be used for pastel painting, and other useful items of 'studio equipment'.

When you visit your local art shop, you will find many different manufacturers' ranges of pastels to choose from, which will all 'mix and match'! You can buy boxed sets of selected colours, or you can browse through trays of pastels in which each colour is offered in a large variety of tints, from the very palest tint to deep velvety tones. Each stick of pastel will be individually wrapped, and identified by colour name and number; you can buy individual sticks to build up your own collection.

Although each manufacturer produces a colour chart, it is important to realize that printers' colours are not always true. I personally like to keep my own colour chart. I make a mark with the colour on a sheet of paper and write its name and reference number alongside. In this way, when I want to replace a favourite colour, I can do so easily.

▼ A colourful selection of pastels of various kinds.

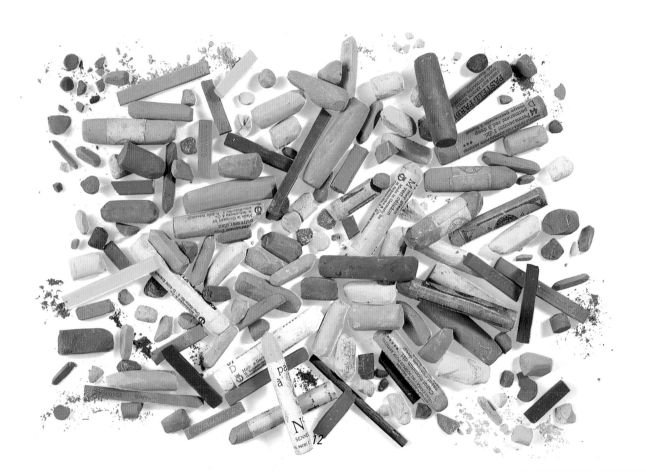

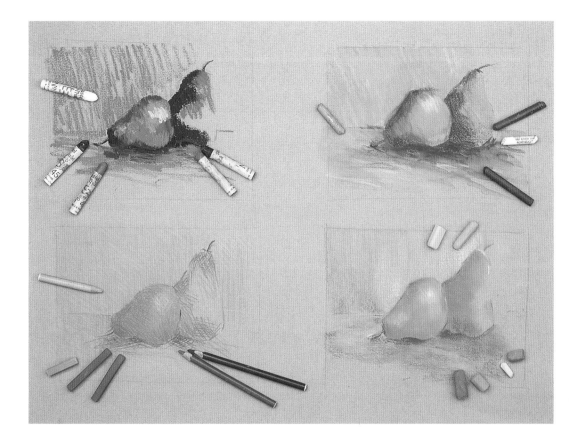

OIL PASTELS (top left)
These pastels contain an oil binder, which makes the texture dense, moist and greasy. The colours are strong, and the variations of colour and tone limited. Oil pastel marks can be softened and spread by brushing with turpentine or white spirit. They can be combined with dry pastel colour to create exciting and unusual effects.

HARD PASTELS (bottom left)
Hard pastels are made with less pigment and more binder, making them harder and more durable. They can be bought in sticks or encased in wood as pastel pencils. They can be intermixed with soft pastels, although it is best to work soft over hard. The firmness of hard pastels makes them a useful sketching medium, since they can be sharpened to a point, and they are excellent for fine details.

WAX PASTELS (top right)
Wax pastels handle rather like oil pastels, but they are less moist. Because the binder is waxy, you can brush over the colour with clean water; the marks dissolve into semi-transparent, slightly grainy watercolour washes. Subtle colour mixes can be obtained by overwashing.

SOFT PASTELS (bottom right)
These are made by mixing ground pigments with a minimum of binding agent. The stiff paste is formed into cylindrical or square sticks, which usually have a soft, velvety texture.

TYPES OF PASTEL

Chalk pastels are the most widely used type of pastel, but there are different sorts of chalk pastel, and also other, more modern ranges of pastel types which have their own specific characteristics.

STORING YOUR PASTELS

In general terms I recommend that you keep colours separated, each in a different box or container. I use boxes, and a large 'artbin' with lots of space to keep the colours in individual compartments.

PRACTICAL TIP

Chalk pastels tend to rub together and pick up colours from each other. To keep them clean, cover the pastels with either ground rice or semolina, shake gently, and then sieve them!

When you are working on a painting, select the pastels you intend to use (or most of them, anyway) and keep them in a separate 'palette' – I use the plastic lid from a box of chocolates! Not only is this lightweight to hold, but I can keep track of small pieces of pastel and my hands stay much cleaner than they would if I held a handful of pastels.

One word of warning – although the pigments used in the making of soft pastels are generally assumed to be non-toxic, it is best not to breathe in too much pastel dust, which can irritate sensitive lungs. If you think you might have a problem in this area, it is advisable to wear a dust mask.

CHOOSING A SURFACE

In choosing a surface to work on, three factors need to be taken into consideration: the 'tooth' (the roughness or smoothness) of the surface, its tonal value (light, medium or dark) and its colour. Although it is possible to use pastel on many different types of surface – even brown wrapping paper or cardboard – there is a wonderfully wide selection of surfaces available in your art shop, from inexpensive sugar paper to beautifully-made pastel papers and boards, varying in weight and texture. The texture of the paper is an important consideration, since pastel adheres to the paper by gradually filling the surface indentations.

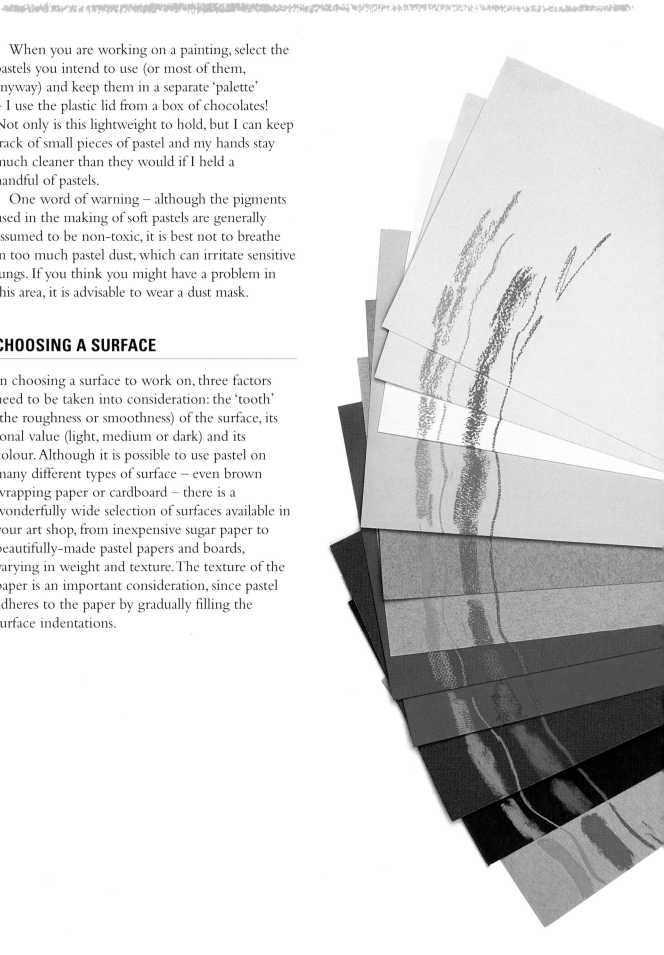

These surfaces include (from the top) three watercolour papers, a selection of five pastel papers, pastel board, and two examples of sanded pastel paper.

WATERCOLOUR PAPER (1–3)

Watercolour paper will give a roughly textured look, and it works well if you underpaint in acrylic, watercolour or gouache.

PASTEL PAPER (4-8)

Pastel paper is usually more textured on one side than the other, which will allow you to choose the surface you prefer. These papers are available in a large selection of colours, from softly muted greys and beiges to brilliant jewel colours, and rich dark tones as well as black. The subtle lighter colours will blend with your pastels; stronger colours will provide dramatic contrast.

PASTEL BOARD (9)

Some types of pastel paper are mounted on board, giving them greater resistance to damage in handling. Surfaces vary, some having a velour-type finish, while others are like a gentler variation of sanded paper, holding the pastel well and requiring little fixative.

SANDED PASTEL PAPER (10-11)

Also known as glasspaper, this paper has a sturdy, granular surface which grips the pastel and allows a dense build-up of colour, making it possible to overpaint many times. If you work with small pieces of pastel, it will wear down your fingernails, and if you aren't careful, it will shave your knuckles too!

FIXATIVES

Pastel fixative is a thinly diluted varnish that is sprayed onto the pastel to secure the particles to the surface. Spray cans are now available in ozone-friendly form; I personally favour the odour-free variety. You can also buy fixative in glass bottles, with a mouth-held diffuser. These are useful for travelling, as many airlines will not allow you to carry spray cans.

There is much controversy about the use of fixative, but there are no hard and fast rules. Spraying while a painting is in progress is, in fact, a useful tool. Not only will spraying provide a fresh surface, enabling you to work over certain passages, but it will also have a darkening effect on the colours, which can be helpful at times!

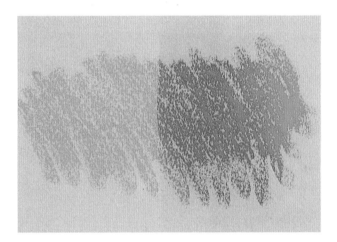

Here you can see how a heavy burst of fixative has darkened the right-hand side of the pastel.

PRACTICAL TIP

My main word of advice where the controversial use of fixative is concerned is to use it lightly as often as you like while a painting is in progress, but give the finished work a very light spray only, if you feel you need to at all.

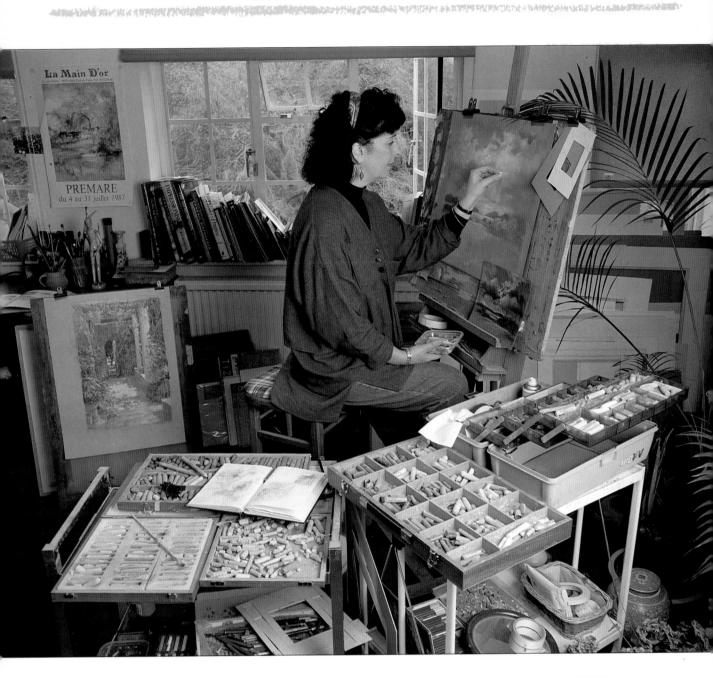

The author at work in her studio. Pastels inevitably occupy lost of space, but some organization helps to prevent confusion!

DRAWING BOARDS AND EASELS

Almost any firm, even surface with no lumps, bumps or knots will serve as a drawing board to rest your work on. Secure several sheets of paper to the board with masking tape, underneath your working surface, to act as a 'cushion' against the grain of the wood.

Although it is possible to work at a table, resting your board on your knees, it is easier to view your picture at arm's length if you stand at an easel. Do make sure that your easel is well-made and sturdy enough to remain upright and steady as you paint!

OTHER USEFUL ITEMS

A trolley I keep all my materials on a trolley, which I can wheel around with ease.

Charcoal Soft vine charcoal is very compatible with pastels. It is excellent for the initial drawing stages, since it dusts off easily without leaving heavy smudges.

Tissues These are useful for blending or dusting off areas of charcoal. An inexpensive alternative is soft toilet tissue.

A stiff hog-hair brush paintbrush This is useful for making corrections by removing surface pastel.

One-sided safety razor blades These serve the same purpose. Scrape gently downwards to remove unwanted layers of pastel.

A mirror Viewing work in a mirror reverses the image, which enables you to see your painting through 'fresh eyes'. Areas in need of adjustment will suddenly become obvious.

Torchons These are pencil-like rigid tubes of rolled paper used for blending – almost the equivalent of having an extra long, thin, pointed finger to work with! They work best on pastel paper; if you use them on sanded surfaces, they shed paper which will become embedded in your colours.

Mounts A mount is a 'window' cut from a piece of stiff card, large enough to put around your painting in progress, so that you can isolate it from its surroundings. You can also use two L-shaped pieces of card.

A viewfinder A small card 'window', very useful to help select a 'view' when searching for compositional ideas.

Sketchbooks These are not just useful, but essential. I will discuss the use of sketchbooks in more detail in Chapter 8.

Pencils I keep a selection of different pencils for sketching: graphite pencils (HB, 2B, 4B and 6B); charcoal and carbon pencils, both soft and hard; and coloured wax pencils.

OUTDOOR PAINTING EQUIPMENT

Do consider how far you might have to walk and how much you can physically carry! I use a large rucksack, and when I'm feeling feeble, I use luggage wheels! As well as my pastels, I usually take the following:

- A lightweight sketching easel
- A sketching stool – useful as a table too
- A drawing board, paper attached, or a spiral-bound pastel pad
- A blow-up cushion
- A viewfinder and camera
- Tissues and moist handwipes
- A sketchbook and pencils
- A plastic bag to cover my drawing board

It is easy to lose track of time when deep in concentration. On sunny days you will burn if you do not take proper precautions; in very cold weather, I advise lots of layers and, in particular, thick-soled boots. Forethought and planning will prevent your painting trip from becoming an endurance test!

At the end of the day, simply turn your pastel to face your board and clip it into place. Secure a plastic sheet over the top, or put your board into a plastic bag. I make no apologies for an obvious suggestion – I have seen countless students gingerly carrying pastels home face-up. They inevitably brush against something and spoil their day's efforts.

PRACTICAL TIP

Sketching easels aren't ideal on windy days – even when 'anchored' to the ground with ingenuity. The wind will buffet your board, and working on a moving surface is most distracting. It is best to find a sheltered spot in which to sit down, and rest your board on your knees.

PASTEL TECHNIQUES

I wonder how many of you were taught to play the piano as a child? If you were, I'm sure you will remember the 'Five Finger Exercises' you had to practise time and again! Although they were rather a chore, they familiarized you thoroughly with the instrument, and were a necessary part of the whole learning experience.

Practising how to manipulate your art materials is exactly the same, and just as important. Eventually, using your materials in different ways will become second nature you. You will find yourself making decisions as you work, relating the techniques you use to your chosen subject quite spontaneously, and this is as it should be. Many students are convinced that conquering technique will solve all painting problems. I'm afraid that this is not so. Over-concern with technique can be dangerous, as a painting which is technically excellent isn't necessarily a good painting! Technique should be an integral part of concept and design. However, this is jumping ahead a little. Let us first look at some of the many different ways of using your pastels.

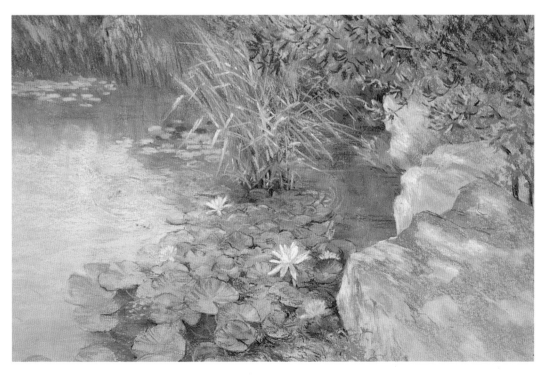

Rocks and Waterlilies, 46 x 73 cm (18¼ x 28¾ in). A neutral warm beige paper can just be seen through the shadows on the rocks. Various pastel techniques have been used here: layering on the rocks; stabbing marks for the foliage; blended areas and side strokes in the water.

LINEAR STROKES

These are achieved by holding the pastel like a pencil, with the point or corner edge against the surface of the paper. You can then create 'line'. Softer pastels will make thick linear strokes, hard pastels will produce a fine, thin line and a pastel pencil will give an even finer, more delicate line. The marks will vary according to the amount of pressure you use, and the surface of the paper will cause the quality of the strokes to vary greatly.

Linear strokes with soft pastel

Linear strokes with oil pastel

Linear strokes with hard pastel

Linear strokes with wax pastel

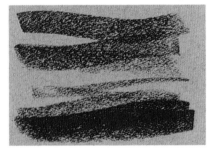

▲ CROSS-HATCHING

Linear marks can evolve into cross-hatching. The lines criss-cross each other in varying directions. Tremendous variety and density can be achieved in this way. You can intermix and overlay the cross-hatched strokes with different colours for subtle colour mixtures.

▲ SIDE STROKE

One of the most beautiful strokes in pastel painting, this is achieved by holding the pastel on its side against the surface to create a 'blanket' effect, excellent for covering large areas. Pastel can be applied heavily for a dense finish, or with light pressure to allow the colour of the paper to show through.

▲ STABBING MARKS

These will create different textural effects, and can also be used for colour accents and highlights.

PASTEL STROKES

Technical expertise does not necessarily guarantee a good end result when using pastels, but it is nevertheless very useful to have a wide knowledge and understanding of your materials, and what they can be asked to do. Technical expertise simply gives you an arsenal of 'tools' with which to work, to help you say what you want to say in your paintings.

▲ BLENDING

This is the mixing of two or more colours on the surface of the paper to create a smooth, velvety finish. You can blend with fingers, with tissues or with a torchon. Please be careful with this technique – too much blending in a painting has a tendency to dull and deaden the colours. Used selectively and in combination with other, more lively pastel strokes for contrast, blending can add richness and unity to a painting.

▲ GRADATIONS

Moving subtly from one colour or tone to another can be achieved by using any of the techniques and needs careful practice. Gradations will prove essential in figurative painting in order to model form and volume. This technique is also necessary in landscape painting, for example to convey a sense of space or atmosphere as the eye moves gradually from areas which are fully saturated in colour to lighter or darker tones and colours.

▲ LAYERING

Layering is just what it says it is – overlaying colours to allow hints of previous applications of pastel to show through. Layering is usually effected over flat colour areas which have been fixed, and the under-colour will modify the newly applied colour. Working light over dark will create a slightly shimmering effect; dark colours drifted over lighter ones will subdue. Cool colour over warm, or vice versa, will add depth and interest.

BROKEN COLOUR

Short, stabbing strokes are the basis for painting areas of broken colour. By using short strokes of pastel, or perhaps dots of colour, mixing colours as you work, you can build up areas which are lively and vibrant.

Building up broken colour in oil pastels

▼ STIPPLING

By varying the pressure you use, you can create any size of dot, or blob, of colour. It can be time-consuming, but can be used to great effect if the subject lends itself to this treatment. The finished image seems to dance with light and vibrancy; the colours glow on the surface.

Broken colour on subdued background of pastel paper

Broken colour on strong background of pastel paper

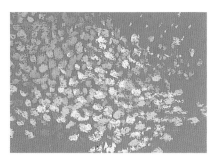

▶ PASTEL OVER
WATERCOLOUR
Watercolour has wonderful
transparency as well as
luminous colour, and the
transparency of watercolour
washes is best exploited by
using white watercolour
paper as your support. Do
stretch the paper to
prevent buckling.

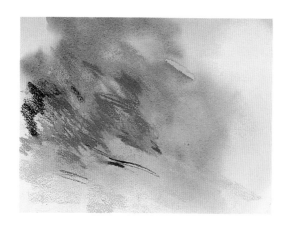

▲ PASTEL OVER GOUACHE
Gouache is an alternative to
watercolour. It is also mixed
and diluted with water, but it
is opaque. A gouache
underpainting will provide
areas of solid, flat colour,
which can add weight and
density to an image.

▲ PASTEL WITH CHARCOAL
Charcoal and pastel mix
together naturally. Charcoal
can be used for the initial
stages of a painting as a
'thinking tool' to work out the
basic drawing and patterns of
light and dark; this early stage
can be completely obliterated
by subsequent applications of
colour. Alternatively, because
charcoal is similar in
texture to soft pastel, it can
be allowed to play an
important part of its own in
enhancing the final image.

PASTEL AND OTHER MEDIA

It is possible to mix pastel with many types of
media, for example, oil paints, watercolours,
gouache, acrylics, ink, charcoal. In fact, mixed
media is an entire subject in its own right and
complete books have been devoted to it. I would
like to introduce you to the simplest and perhaps
most useful 'mixes'.

Although pastels are usually executed on
coloured paper, it is exciting to create your own
coloured background by beginning with paint.
You can use several different colours for this
underpainting; this will give you an interesting
multicoloured surface to work on, and these
changes of colour can be allowed to show subtly
through subsequent applications of pastel.
Sometimes it is difficult to create dark areas with
pastel. There are far fewer dark pastels than
medium or light-toned ones, and adding black is
seldom satisfactory as it can deaden colours. Deep,
rich, dark areas can be achieved by first painting-in
dark washes.

EXERCISE

Areas of broken colour are fun to experiment with. Try using
several shades of one colour for a vibrant single colour
effect. Then try combining different colours of a similar tone
– pale blue, pale pink, pale green, for example. Finally, try
colours which contrast strongly. In all cases, be aware of
the contribution of the colour of the paper. Look at Degas
for inspiration.

PROJECT
PRACTISING WITH PASTELS

Medium
Three pastel sticks in as many
of the following types
as possible:
Soft pastels
Hard pastels
Pastel pencils
Oil pastels
Wax pastels

Colours
Different colours of
your choice

Paper
Light-toned pastel paper
Dark-toned pastel paper
Glasspaper or pastel board
with a velour-type surface

Size
Full-sized sheets,
approximately 45 x 55 cm
(17¾ x 21¾ in)

Equipment
Tissues and a torchon
Fixative
A charcoal stick
Drawing board and clips,
pins or tape

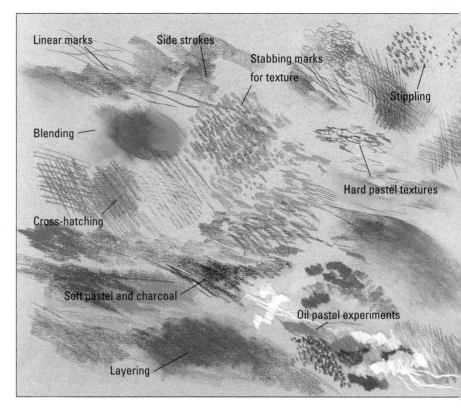

It is fun to experiment with pastels in a lively, unpressurized kind of way; it will feed you with information and give you confidence to tackle the awesome task of picture-making. Working freely across each sheet of paper, try as many of the illustrated techniques as possible. I suggest that you do not try to create recognizable images – if you do, you are likely to be more concerned with the image than the technique you are practising.

If you can manage to repeat the project with all the different types of pastel, so much the better. I know this means buying lots of pastels, but all pastels have a virtually limitless shelf life; they won't dry up in the cupboard and have to be thrown away unused. You may feel inclined, at a later date, to go back to the ones which didn't appeal initially.

If you decide to extend the project and try an underpainting, you need only purchase one or two tubes of gouache paint. Used very diluted, it will closely resemble pure watercolour.

◀ This sheet shows a variety of pastel techniques, worked with soft pastels, hard pastels, oil and wax pastels. Working freely like this is an excellent way to become familiar with your tools.

▶ Soft pastel over a watercolour wash.

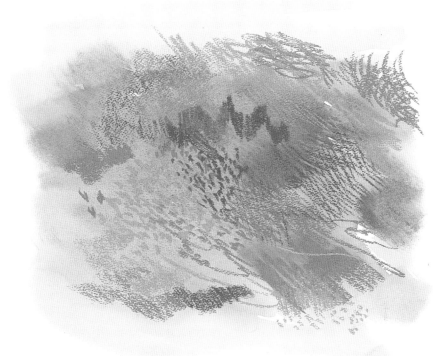

▼ Oil pastel and wax pastel on dark-toned paper.

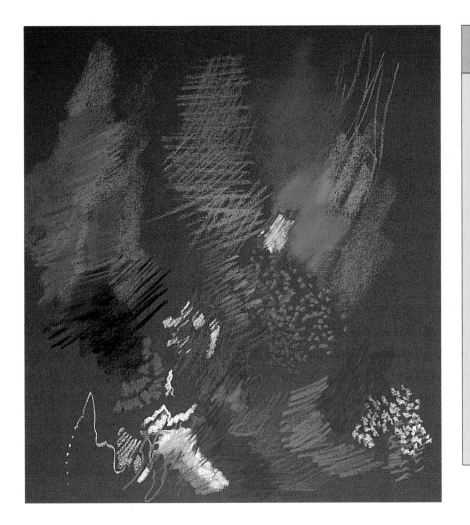

SELF-ASSESSMENT

- *Did you remember to vary the pressure of your pastel strokes?*

- *Did you use the side as well as the point of the pastel?*

- *Did you notice how the colours of the pastels were affected by the colour of the paper?*

- *Did you manage to control the pastel to make exactly the marks you wanted? If you did not, perhaps you should try again.*

UNDERSTANDING TONE

The word 'tone' in painting is used to describe how dark or light an area is, regardless of its colour. The most effective way to visualize this is to imagine your subject, or painting, reproduced as a black-and-white photograph. Look at black-and-white photographic images in your daily newspaper – these are excellent examples of 'tone'.

Without a pleasing arrangement of light, medium and dark tones, not only will a painting and the objects within it look flat, but it will also lack balance and harmony. Passages of light or dark tones will help to move a viewer's eye through a painting; areas of similar tone will unify a design and contrasting tones will attract attention.

Tumbledown Shed, Vasiliki, 38 x 52 cm (15 x 20½ in). A black-and-white photocopy of this image would demonstrate tone perfectly.

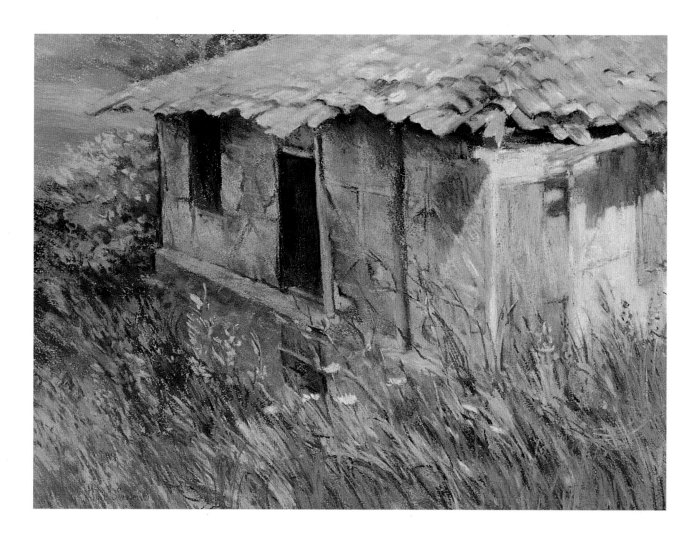

LOCAL COLOUR AND TONE

When we look at an object, we are immediately aware of its 'local' colour and tone. The local colour is usually obvious – for instance, apples are green (or perhaps red); a carrot is orange; a daffodil is yellow, a lump of coal is black. Local tone is the relative lightness or darkness of those objects – a green grape is lighter in tone than a black one, and some green grapes may be lighter in tone than other green grapes.

When we come to draw or paint these objects, these local tones are also affected by the light. A bright light shining on a bunch of green grapes will affect the tones dramatically; the side nearest the light will have a much lighter tonal value than the side away from the light, in shadow. In fact, the shadow side of a pale green grape might even appear as dark as a black grape! At the same time, the light will be describing the forms of the grapes.

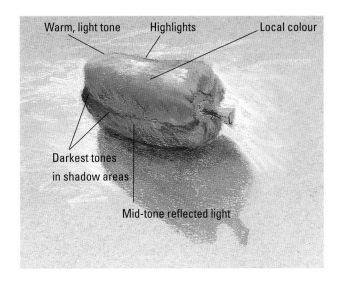

Warm, light tone Highlights Local colour

Darkest tones in shadow areas

Mid-tone reflected light

This sketch of a pepper shows local colour and tone.

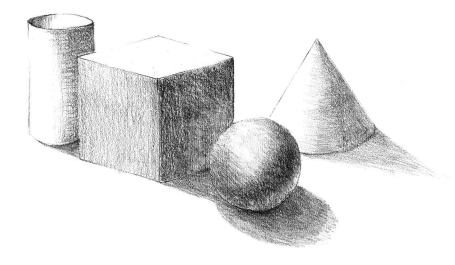

By changing from dark to light tones, the form of these geometric shapes becomes apparent.

LIGHT AND FORM

When light falls on an object, its three-dimensional nature becomes easy to 'read', basically because of the shadows created by the light. When you begin to draw, it sometimes helps to recognize that all forms can be said to relate to simple geometric shapes – the cube, the cone, the cylinder and the sphere. These shapes can be used to clarify your understanding of any object, and how the light will define its form. There are many straightforward examples.

- The cube – buildings, boxes, books
- The cylinder – tree trunks, bottles, flower stems, arms and legs
- The sphere – bowls, balls, many kinds of fruit such as apples and grapes
- The cone – mountains, flower heads, fir trees

In rounded objects, the tone must be 'modelled' by following the curve of the surface as it turns away from the light. Cubes are easiest of all, the changes of plane being revealed by its angles.

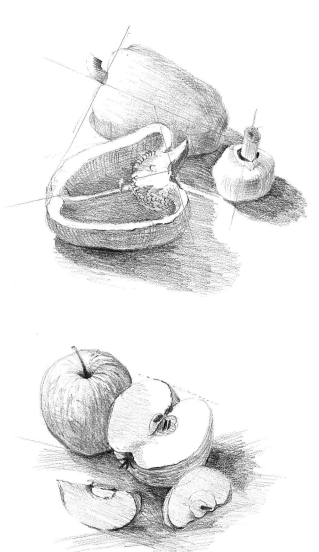

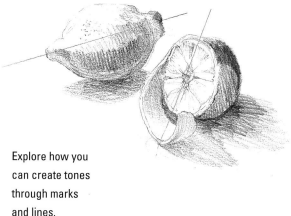

Explore how you
can create tones
through marks
and lines.

TONES IN DRAWING

When we use a pencil, we are forced to translate colour into black, white and greys, and in so doing, we train ourselves to think in terms of tone. It is a good idea to practise using pencils and charcoal (which can also be bought in pencil form) to explore a range of marks and lines, depth and lightness of shading, patterns and textures. Practise drawing as often as you can, breaking your subject down into its main tones – lightest (or white), light grey, medium grey, black. The white paper will be the lightest tone; black can be achieved by using your softest grade of pencil – 4 or 6B. Once you have established the main tones, you can work more subtle variations into them if you wish to take the drawing further.

EXERCISES

1 Start by drawing single objects, such as fruits or vegetables, an old hat or even a crumpled piece of paper, and as your confidence develops, build up to still life arrangements or little scenes. The more you practise, the easier you will find it to translate colour into tone.

2 If you find it difficult to translate colour into tone, here is a simple exercise which will help to train your eye. Try cutting a variety of light, medium and dark coloured patches, approximately 2.5 cm (1 in) square, from a magazine. Stick them down in a row, and underneath each square, try to match the tone as closely as you can with pencil shading.

TONAL STUDIES

The distribution of dark and light areas in a painting plays a large part in the making of a successful, harmonious, balanced design. If, before you launch into a painting, you spend a little time on some tonal studies which sort out the main shapes and masses of tone in your subject, you will be pleasantly surprised to find how very helpful these studies will prove to be, and how a well-designed arrangement of tones will hold the picture together and give it an underlying strength.

Group closely toned areas together so that you create a pattern of fairly large, flat, abstract shapes. Reduce your subject to its simplest light, medium and dark tones, and you will very quickly be able to assess whether the balance is right. Trust your intuition – it is much easier to alter things at this stage than when the painting is well under way.

Tonal studies are also an excellent way of simplifying complex subject matter, and of 'making friends' with the subject before you begin to paint. They sharpen your perception, and you begin to see your subject as a painter rather than as a casual observer.

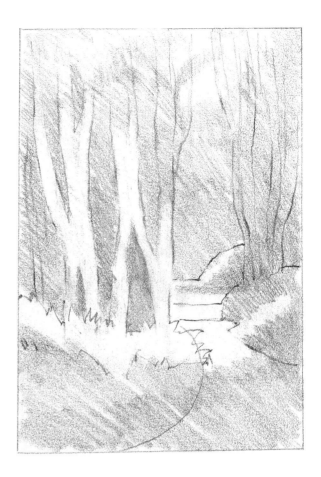

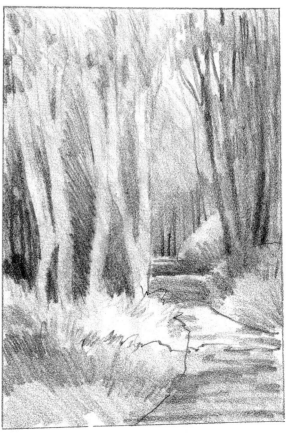

The drawing above shows the first application of tone – the main light and dark areas of the scene. On the right, the study now contains light, medium and dark tones.

PRACTICAL TIP

As you work, I recommend that you occasionally screw up your eyes and peer at both your subject and your painting. In this way, you will eliminate much of the colour and detail, and will better be able to assess tonal values.

Fruit Tonal Study

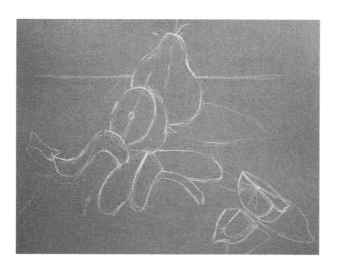

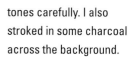

▲ STEP 1
I drew the objects and their cast shadows on grey pastel paper, using a white conté stick (although I could just as easily have used black). Notice the direction lines on the pear and lemon – it always helps to establish the angle of tilt when an object isn't completely vertical.

Also, I used faint lines to plot the positions of the objects in relation to each other.

▲ STEP 2
Having spray-fixed the drawing, I roughly defined the darkest areas of the image with charcoal, linking shadows to objects initially and then overworking the charcoal in places to define shapes. I fixed again, and then defined the dark areas more positively, graduating

tones carefully. I also stroked in some charcoal across the background.

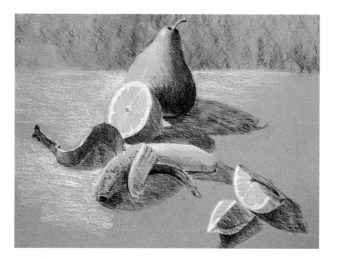

◄ STEP 3
The next stage was to add the most obvious light parts of the image, allowing the grey of the paper to modify the white in places, such as on the surfaces of the lemons and the curve of the banana.

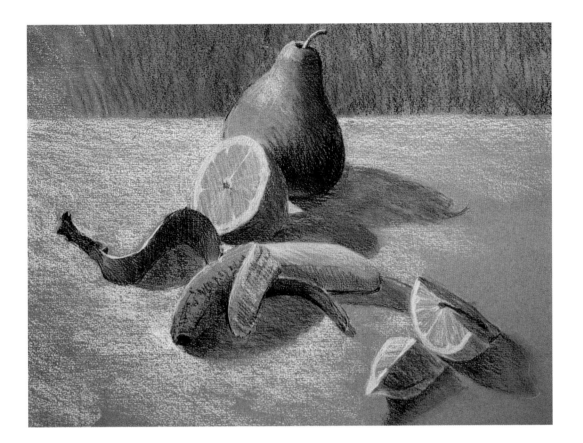

▲ STEP 4

Finally, I worked across the whole image, observing and adjusting tones where necessary. The background was darkened fractionally and the table-top completed.

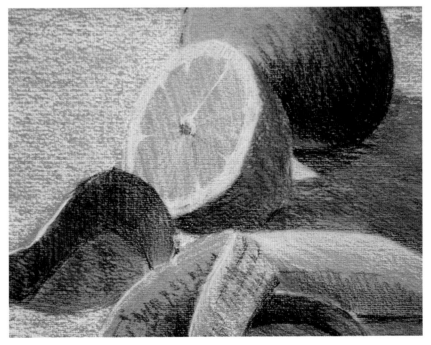

▲ DETAIL

This detail shows how the charcoal and white pastel were applied. The side of the pastel was used for the table-top, while side strokes and cross-hatching with the point of the charcoal were used on the fruits. Notice how the untouched grey paper is an effective middle tone in several places.

PROJECT
LEARNING TO SEE AND DRAW TONE

Medium
Pencil
Charcoal
Conté crayon

Colours
Black and white

Paper
Two sheets of white
cartridge paper
One sheet of medium-grey
pastel paper

Equipment
Graphite pencils (HB, 2B, 4B)
Charcoal
One black contécrayon
or pencil
One white conté crayon
or pencil
Two or more green peppers

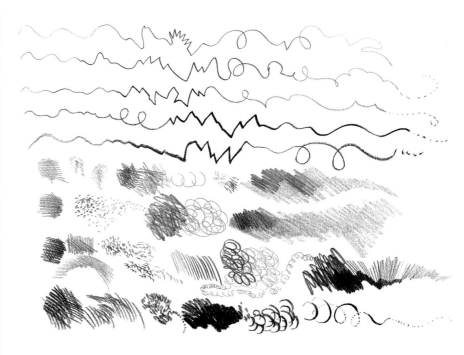

This project offers a series of exercises designed to help you to 'see' tone, and learn how to render it faithfully. If you are a complete beginner, it would be sensible to tackle each exercise consecutively.

Begin by producing a 'warm-up' sheet like mine, shown above. Cover the sheet with as many marks as possible – lines, cross-hatching and scribbles. Create areas of light, medium and dark tones. You do not necessarily have to increase the pressure on your pencil to darken the tone; you can build up tone by over-drawing. Compare the range of tones available in the different types of pencil.

When you have completed this sheet, take a fresh sheet of paper and draw a column of ten 2.5 cm (1 in) squares. Fill them with pencil tone, darkest at the top grading through gradually to lightest at the bottom.

▲ A 'warm-up' sheet' of marks made with graphite pencils, charcoal and carbon pencils.

◄ Grade the tones carefully, so that the progression from dark to light is a smooth one. When you have completed your strip, look at it through half-closed eyes. Any uneven gradation will immediately jump out at you.

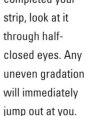

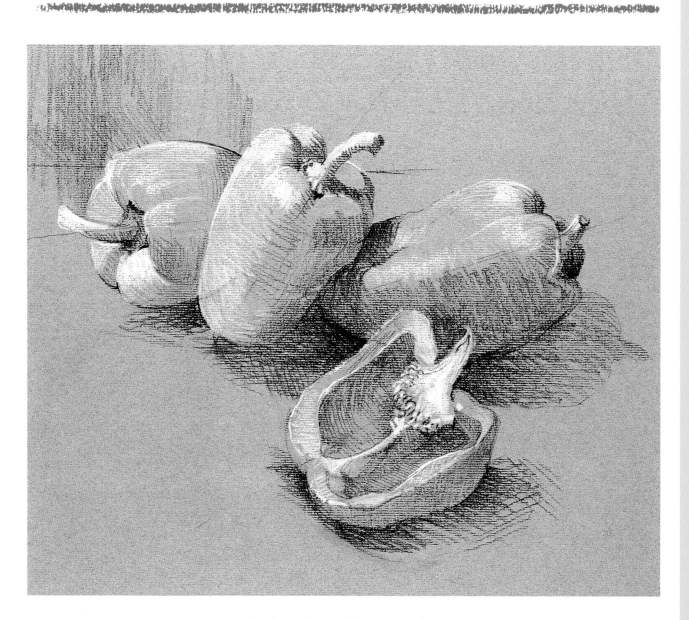

Green peppers are fascinating to draw, and translating their colour into black, white and grey is an excellent way to begin seeing colour as tone. For the final exercise take at least two green peppers, cut one in half and arrange the pieces on a table, ideally using one light source only. Draw the peppers on your sheet of grey pastel paper, using black and white conté crayons. By varying the pressure on your chalks, or building up with cross-hatching, you can produce a wide range of tones which will 'mix' optically with the fixed, medium–grey tone of the paper. Do not mix black and white to produce grey. Greys should either result from the black or white marks being 'mixed' with the grey of the paper. Look first for the simple light, medium and dark tones, using white for the light, black for the dark, and the paper colour for the medium tone. Then begin to look for the more subtle, intermediate tones. Do not worry too much about the accuracy of the shape of the pepper – accuracy comes with much practice.

SELF-ASSESSMENT

• *Did you manage to create an even gradation of tone in your strip of squares?*

• *Do your green peppers look solid and convincing? If you have observed the tones simply and accurately, you should have created a good sense of form.*

USE OF COLOUR

To open an art shop drawer full of pastels is to be confronted with a rainbow of colours.

However, although there would appear to be an appropriate pastel for every possible colour in nature, most pastel artists build their pictures by mixing colours – either by blending on the surface, by layering colour over colour, or by leaving pastel marks separate, for the viewer's eye to mix.

Colours interact in fascinating – and confusing – ways, and while it may be fun to achieve good results accidentally, there will be times when you will want to create a specific colour effect. An understanding of colour theory will prove helpful here.

I promise not to 'blind you with science'. My intention is simply to give you sufficient information to help you to use colour creatively.

▶ Richard Plincke, *The Sweep of the Cliffs,* 47.5 x 71 cm (18¾ x 28 in), oil pastel

▼ *Red Still Life,* 45 x 60 cm (17¾ x 23½ in)

THE VOCABULARY

Let's start with the main terms used in relation to colour: hue, tone, intensity and temperature.

HUE
This is the general name of a colour in its purest form – red, orange, yellow, green, blue, violet – the colours of the spectrum. Any hue such as red or blue has many pigment names, for example, Alizarin Crimson and Cadmium Red, or Ultramarine Blue and Cobalt Blue.

TONE
This refers to the lightness or darkness of a hue – for example, light blue and dark blue. Both are blue (the hue), but they are completely different in tone. The effective control of tone plays a large part in the success of a painting.

INTENSITY
Sometimes called 'saturation', this refers to the degree of brilliance or dullness of a colour. As a colour becomes less bright, it progresses towards grey – or neutral. This is often confused with tone, but it is possible for a colour to become less intense without changing tone. For example, a crimson red is a rich, intense tone, but a dull rust red, no lighter or darker than the crimson red, is reduced in intensity.

TEMPERATURE

Colours that are said to be 'warm' are the yellows, oranges and reds. 'Cool' colours are blue-greens, blues, purple-blues and purples. However, there are subtle degrees of warmth and coolness in both categories of colour. For instance, blues that contain some hint of red, and veer towards purple, are 'warmer' than blues which veer towards green. Reds with a hint of blue in them – the crimsons, are 'cooler' than orangey reds.

Do bear in mind, however, that colours change according to their surroundings. A warm colour may appear quite cool when surrounded by even warmer colours. It is useful to remember that when you are trying to achieve a sense of depth in a picture, warm colours appear to come forwards, while cool colours recede.

Red Vase, 45 x 60 cm (17¾ x 23½ in). The warm red vase and warm sunlit areas of stone are offset by cool greens and blues in the foliage and shadows.

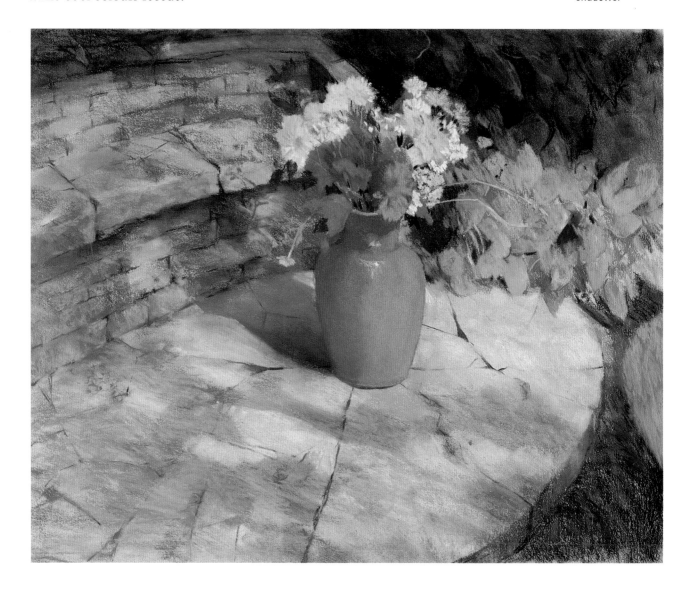

The basic colour wheel (top left) has three primary and three secondary colours. The full colour wheel (above) includes the six tertiary colours. The diagram (left) shows complementary pairs, which are explained in more detail overleaf.

THE COLOUR WHEEL

Memorizing a colour wheel will prove invaluable. If you find it difficult to remember, perhaps you might like to copy mine into your sketchbook.

All colour originates from the primary colours – red, yellow and blue. Secondary colours are produced by mixing the primary colours to produce orange, purple and green. These six colours form the basic family of colours from which all other colours originate. Tertiary colours are a mix of a primary colour with its adjoining secondary – for example, red (primary) and orange (secondary) produce red-orange (tertiary).

EXERCISE

Take a piece of white card measuring approximately 35 x 30 cm (14 x 12 in) and cut a rectangular hole in the centre measuring 15 x 10 cm (6 x 4 in). Pin the paper to a suitable tree trunk and study the bark through the hole. See how many different colours you can find and write down full descriptions of the colours on the margins of the paper, such as dull greenish yellow, cool blue-mauve, light orange-brown.

COMPLEMENTARY COLOURS

You will often come across the term 'complementary colours' when you read about paintings. When we look at the colour wheel, the complementary colours are the hues that are opposite each other. These colours are sometimes known as 'contrasting' or 'conflicting' colours. When two complementary colours are mixed, they neutralize each other and produce a grey. When placed next to each other, unmixed, they intensify each other and appear brighter than when separate.

The great painters of the past knew their colour theory well. If you have the time and inclination, do look at the works of Eugène Delacroix, J.M.W. Turner, Paul Signac, Pierre Bonnard and Vincent Van Gogh, all of whom studied colour theory and science, and applied it imaginatively in their work. Van Gogh particularly liked to work with pure complementary colour contrasts – his paintings sang with vibrant, dynamic colour.

Convincing shadows can be created by using some of the object's complementary in the shadow area; the use of a complementary colour underpainting, or choice of a complementary coloured ground, will add both interest and excitement to an image. It is fun to experiment with dots and dashes of broken complementary colours. Yellows and violets, for example, will create areas of colour which, viewed from a distance, will appear as an interesting area of grey, with far greater visual impact than a flat, grey colour.

This brings me to an important point – balance. In painting, it is important to remember that equal proportions visually vie for attention, eventually fatigue the eye and cancel each other out! This applies particularly to complementary colour schemes. It is important to allow one colour to dominate. This applies to temperature, too – your painting will benefit from a predominantly warm, or cool, colour scheme.

Complementary colours need care in handling if they are to avoid looking rather brash and obvious. One way to create subtle and interesting colour contrasts is to decide upon the main primary colour to be used; use it in small quantities and surround it with muted, or neutralized, versions of its complementary, for example, primary red with muted greens.

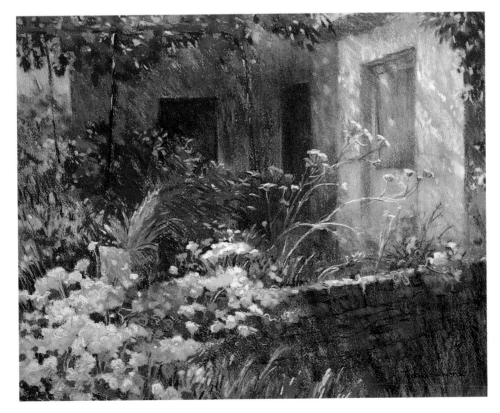

Golden Light, 35 x 45 cm (13¾ x 17¾ in). Sunlit flowers are complemented by purple and blue shadows. The dominant blues and purples are balanced by smaller areas of yellow and orange.

▼ These strips show complementary colours.

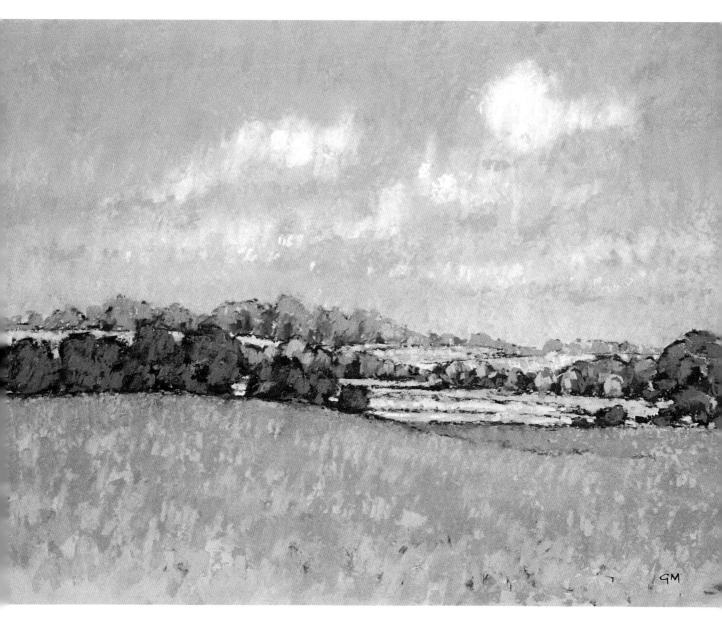

COLOUR HARMONY

One of the simplest and most effective ways of using colour is to restrict your palette to harmonious (or analogous) colours – that is, any group of colours which are adjacent to each other on the colour wheel. So, for example, all colours that are next to blue, or contain blue, will create beautiful harmonies when used together.

Groups of harmonious colours are shown here.

▲ Geoff Marsters, *Field of Borage*, 56 x 76 cm (22 x 30 in). The colour key of this painting is based on blue and clearly demonstrates the effectiveness of a restricted palette. The artist has used blue, blue-purple and blue-green throughout, building up the image with individual strokes of closely related colours in a wide range of tones. Colour harmony is cleverly effected in this way.

COLOUR RELATIONSHIPS

Colours are often affected by other colours which surround them. For instance, when we redecorate a room, old white paintwork suddenly looks grey or yellow next to the new parts. A pale pink vase on a bright blue tablecloth will reflect the blue in places. Yellow becomes yellower against bright blue, greener against green.

The light also affects the way we see colour. A brilliant red flower will appear red-orange in sunlight, and will appear a more subdued red-purple on an overcast day or in the shadow. White is a trap to watch out for. A white door in shadow, for instance, is seldom white – it is far more likely to be blue-grey!

It is easy to see from these simple examples that we must never take colour for granted – observation is the key.

Barry Watkin, *Tally Ho, Rhododendron,* 47 x 62 cm (18½ x 24½ in). The artist has paid great attention to detail and has closely observed many subtle nuances of colour. Notice particularly how the light affects the colours of the leaves. Leaves which face the sky reflect light and are cool blue-green; their undersides are a warmer green, and in places they even reflect brilliant red from the flowers.

EXERCISE

As you go about your daily business, begin to train your eye by making visual comparisons in your mind as you look around. Always compare colour with colour, and notice how the light affects what you see. With practice and keen observation, colour relationships will soon become second nature to you.

THE PSYCHOLOGY OF COLOUR

Colour expresses feelings and reflects emotions in a very definite way, and many studies have been made into the psychology of colour. We all make colour choices in our daily lives – the colours in our homes, for instance, and the colours of our clothes. We are affected by the colours we see around us. It is not just by chance that traffic 'stop' lights are red, or that blues and greens, thought to be restful and healing colours, are often used in hospitals.

The way in which an artist uses colours together, and the degree of tone and intensity he selects, all contribute to the mood, atmosphere and expressiveness of the final image. Your choice of colour scheme can express your feelings about the subject in many different ways. Some colour schemes are rich and dynamic, others quieter and more subdued. You need not always use colours which are true to nature. Sometimes, it is challenging to invent colours which make the image more personal.

Every painting is, in effect, the artist's personal interpretation of the visual world. If colour can be used expressively to reinforce thoughts and feelings, then when we paint, we are allowing something of our inner selves to appear on the surface. No two artists will 'see' things in quite the same way. If you are prepared to take the trouble to organize your colour intelligently and selectively, you will not only express yourself more fully, but you will touch your viewer more deeply. Colour is the factor in painting which stimulates the greatest emotional response.

Copying the work of other artists can be a valuable learning activity. Van Gogh copied the work of Delacroix and claimed that his own painting was 'fertilized' by Delacroix; he felt that the clarity and impact of Delacroix's work had helped him to use colour more arbitrarily.

You could try 'copying' one of Van Gogh's paintings, using pastel – ideally working from as large a reproduction as possible. Assess colour relationships carefully as you work.

Margaret Glass
Evening Tide, Southwold,
43 x 56 cm (17 x 22 in).
It is almost possible to hear the quiet lapping of water against the boats and jetty. Tranquillity is powerfully conveyed by the artist's choice of a mellow golden light, which softens colours and creates an atmosphere of gentle peace.

PROJECT
EXPLORING COLOUR

Medium
Collage
Chalk, oil or wax pastels

Colours
Pastels in a variety of colours
and tones

Paper
Three sheets of pastel paper,
ideally neutral in colour and
medium in tone

Size
20 x 25 cm (8 x 10 in)
minimum

Equipment
Sketchbook
Black scrap paper
Grey scrap paper
Glue

I tore my black and grey paper into random shapes and moved them around inside the rectangle, discarding some and keeping others, until I found an arrangement which 'felt right'.

I have used soft pastels for this image, and a harmonious colour scheme which I based on the primary colour, blue.

The non-figurative painter Kandinsky once said, 'Let your eyes be enchanted by the purely physical effect of colour, like a gourmet savouring a delicacy.' For this project, we are going to make a very gentle foray into the realms of abstraction! This is not meant to turn you immediately into an abstract painter – it is simply that by working with basic abstract shapes, you can concentrate fully on colour for its own sake.

The illustrations on these pages show a paper collage and colour interpretations of it. Collages are simple and fun to do. Draw a rectangle approximately 10 x 15 cm (4 x 6 in) in your sketchbook. Using torn and cut pieces of black and grey paper, move them around in this rectangle, using the white page as your third tone, until you find a pleasing arrangement. You will sense quite quickly when the design is balanced and harmonious. When you are happy with your design, glue all the pieces in position on the paper.

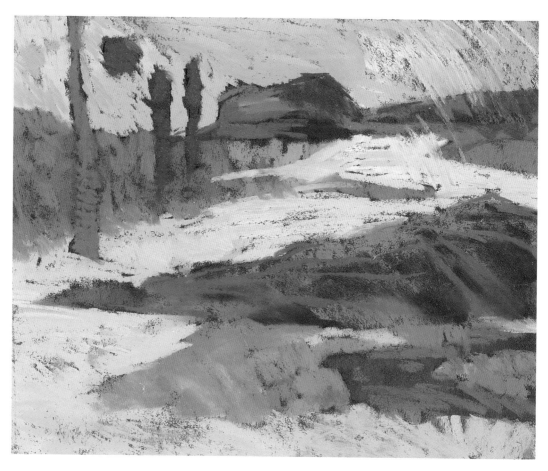

This small image was worked with oil pastels on paper, using a primary colour and its complementary. Because I was under no pressure to produce a recognizable picture such as a bowl of fruit or a scene, I felt a great sense of freedom – and fun too!

Now make three colour interpretations based on your designs, using:

• Harmonious colours

• A primary colour and its complementary

• An arrangement of warm and cool colours

You do not have to produce large paintings, but the larger you work, the more freedom you will have to experiment with colour.

If you enjoyed working in this way, you could extend the project to increase your understanding of colour even further. Repeat the process on a variety of different coloured papers, for instance, and notice how the paper colour affects the end results. Also, you could try using earth colours only; a range of light, bright (high-key) colours; or a single colour in a variety of tones. There are probably many more permutations. Do feel free to be experimental – it's the best way to learn!

SELF-ASSESSMENT

• *Were you able to translate tone accurately into colour value?*

• *Viewed from a distance, do the cool colours in your picture recede and the warm ones advance? (They may not – it depends on the composition, but it is useful to consider the question.)*

• *Do your images have either effective colour contrast, or colour harmony?*

SPACE AND PERSPECTIVE

Something fascinating happens when an artist works on a two-dimensional support – a flat piece of paper or canvas – and somehow manages to create depth so that the viewer feels as though he is looking through a 'window' into a three-dimensional world. This is, of course, an illusion, and in this chapter we will examine how to create this illusion, which is useful no matter what our subject may be – the great depth and space of a landscape, or the limited space of a still life.

Perspective, to many aspiring artists, sounds rather like a punishment, not unlike 'detention' or 'filling' (apologies to all dentists!). You may like to know what John Ruskin wrote in 1856 in his book The Elements of Drawing: 'Turner, though he was professor of perspective to the Royal Academy, drew buildings only with as much perspective as suited him.' Ruskin recommended that students should 'treat perspective with common civility, but pay no court to it.' I think he meant that we shouldn't be slaves to perspective, but treat it as a useful tool for checking and correcting things which don't look quite right. Learning the basics needn't be too much of a chore, and time spent now will no doubt be of practical benefit later.

David Mynett,
The Doge's Palace,
40 x 51 cm
(15¾ x 20 in),
pastel over
watercolour.
Cool blue-purples
help to push the
beautiful, softly lit,
distant buildings
back in space. The
strongest colours
in the painting are
reserved for the
foreground water.

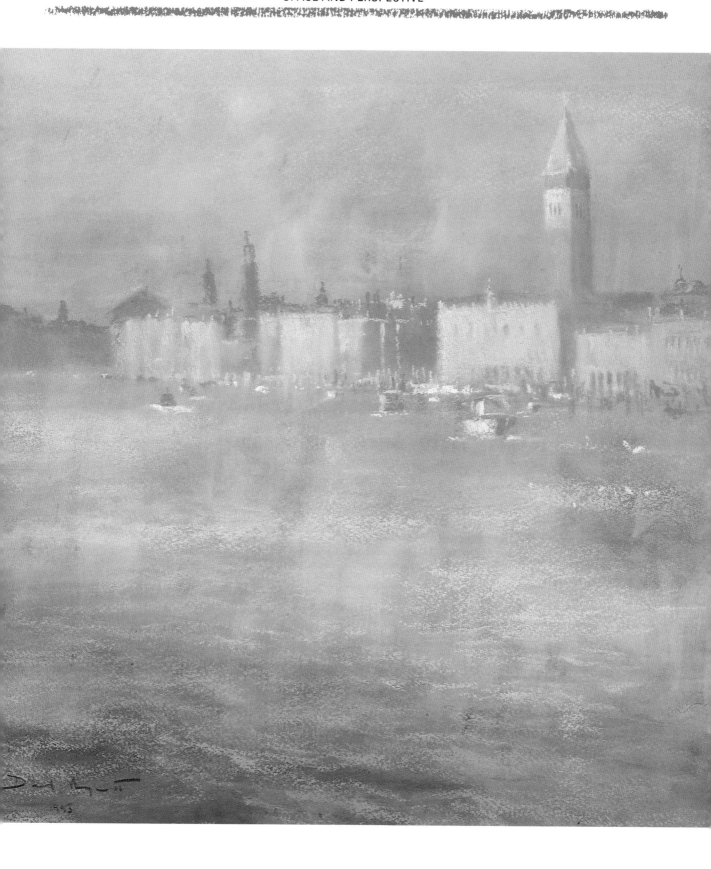

Lionel Aggett,
Olive Grove, Les Alpilles, Provence,
50 x 62 cm (19¾ x 24½ in).
All the main elements of aerial perspective are evident in this painting and contribute to the marvellous sense of space and depth: warm foreground colours with strong tones; overlap and change of scale in the trees; cool blue distance.

AERIAL PERSPECTIVE

Before we tackle the geometric aspect of perspective, let us look at a rather different but equally important aspect of perspective – aerial perspective. This is sometimes called 'atmospheric' perspective, because it relates to the optical effects of vapour and dust particles which hang in the air and 'interfere' with what we see. Tones and colours of objects gradually change as the distance increases – the tonal contrasts lessen, the colours become bluer, edges and textures soften.

Students frequently paint what they think is there, rather than what they see. They know that the distant trees have brown trunks and bright green leaves, so they use those colours and tones even though the trees actually have a cooler, more bluish tinge than those in the foreground or middle distance. It can be hard to see subtle nuances of colour, but it is important to manipulate the colours and tones of the painting to create a convincing illusion of space.

Aerial perspective can be suggested in other ways too, by using overlap, change of scale and variety of texture, as the diagrams (right) show.

Overlapping is a simple way of creating an illusion of depth.

If overlapping is combined with size differences, the spatial sensation is greatly increased.

Depth is created when texture is emphasized in the foreground or middle distance, and softened in the distance.

LINEAR PERSPECTIVE

Understanding the basic 'rules' of linear perspective will, I am sure, help you to improve your drawing and painting. However, you cannot apply these rules without recognizing the importance of properly measuring proportions and assessing angles. As a student I was always encouraged to use eye and judgement first to measure proportions and angles, and then use perspective as a double-check.

Proportions, particularly in landscape painting, can really surprise you. A distant meadow, for instance, which you 'know' to be quite large, may only occupy the tiniest of spaces when you come to measure it for drawing. Side planes of buildings are often much narrower than you think – the tendency is to draw a wide shape, because you 'know' that the building is really quite deep.

MEASURING ANGLES

Angles can be quite simply assessed by holding out your pencil and aligning it with the angle you want to draw. This is a very useful aid to drawing – it is certainly the one I use the most. A word of warning, however. I have watched countless students tip the pencil away from them, pointing it at the subject, when trying to assess angles or lines which move away from them in space. Although this is a very natural reaction, you must remember to keep the pencil at right angles to your outstretched arm, as if you were holding it flat against an imaginary window or sheet of glass. If you point it at the subject, this simply foreshortens the pencil!

Another method is to hold your sketchbook up behind your pencil after you have 'lined up' against the angle. Then you can note the angle on the page.

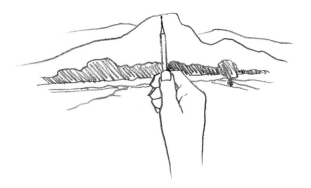

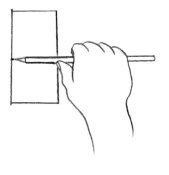

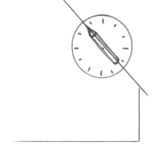

HOW TO MEASURE

You need to make sure that your viewpoint is fixed. If you move, the positions of the objects alter. Bear in mind that your proper 'field of vision' is only about 45-60 degrees. Stretch your arms out in front of you, and gradually open them until they begin to disappear from your vision. Anything out of this field becomes distorted and out of focus, so please try not to turn your head from side to side as you work, to take in a wide-angle view!

Always shut one eye as you measure. Two eyes give us binocular vision, which moves the view-point. You can prove this to yourself by looking at two objects which are close to each other, shutting alternate eyes. You will discover that the distance between the objects alters!

Use a pencil or ruler as a measuring device. Hold it at arm's length from you – lock that elbow! The top of the pencil should be level with the top of the upright you wish to measure. Run your thumb down the pencil until it is level with the bottom of the subject. (Measure horizontals in a similar way, but sideways.) Measuring will help you to transfer and compare proportions as you draw. For example, the width of a doorway might 'go' exactly three times into its height.

The 'clockface method' is a most effective way of assessing angles. Line your pencil up with the angle you want to draw. Then in your mind's eye, allow the pencil to represent the hands of a clock and see what 'time' it is. Transfer this 'time' as accurately as you can onto your paper.

No matter whether you are standing, sitting or lying down, the horizon will always be at your eye-level.

PERSPECTIVE CONSTRUCTION

A fundamental aspect of linear perspective is the 'eye-level' – which is basically the horizon. It isn't at all difficult to find the horizon when you are standing on a beach looking out to sea. However, often there is no obvious horizon. Hills, houses, walls or foliage may block our view, and in the case of a room interior or a still life, the word 'horizon' seems totally inappropriate.

So we'll stay with the term 'eye level'. Whether you stand or sit to work, the eye-level line is simply a horizontal extension of the direction of your gaze. If you hold your closed sketchbook right in front of your eyes, with the spine of the book resting on the bridge of your nose, and you look out across the top of the book – *that* is your eye-level.

If you find it difficult to 'see' and understand perspective at all, try taking a sheet of clear perspex (or even use a window with a suitable view) and, looking through it, trace the outlines of an outdoor view onto it with a felt-tip pen. You will have an accurate drawing of the scene, in perspective, with the spaces and sizes of objects properly in proportion. As students we were always encouraged to imagine this piece of perspex or glass in our mind's eye as a drawing aid, and I still use this technique today.

There are many useful 'rules' of perspective, and if you intend to tackle complex subject matter such as inclined planes (staircases, hillside s treets, half-open box lids), division of space into equal parts, or shadow perspective, I recommend that you search out one of the many comprehensive books on perspective available in bookshops or libraries.

I offer you here some of the very basic 'rules' of perspective, which hinge on the concept that lines which are actually parallel in the real world appear to meet at a single point on the horizon if you extend them.

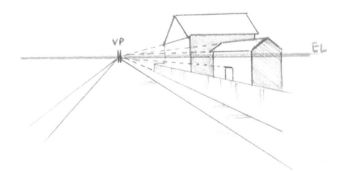

ONE-POINT PERSPECTIVE
You must be centred on your subject. Imagine standing in the centre of a road, which stretches away from you into the distance. The lines above your eye-level will move down to the vanishing point, and lines below your eye-level will move up to the vanishing point. Horizontals and verticals remain unchanged.

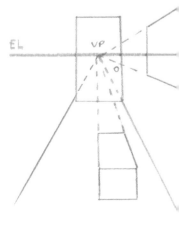

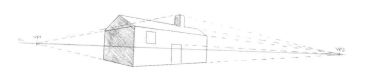

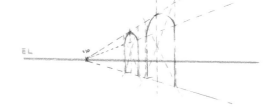

▲ TWO-POINT PERSPECTIVE

This occurs when we are at an oblique angle to our subject, seeing it corner-on, for example, when we look at the corner of a building so that two sides are in our view. (The same thing applies to a carpet, a table-top, a book, etc.) In this case, there will be two vanishing points on the eye-level line. Notice that the top of the chimney in the illustration obeys the same rules of perspective.

▲ PERSPECTIVE CENTRES

It is useful to know how to find the centre of a wall or surface which turns away from you – for example, to find the position of the top of a gable on a house, or to locate the exact position of a central window. The blue construction lines show how to find the perspective centre. Be sure to measure the height of the gable accurately. Here, the height of B-C is half the height of A-B.

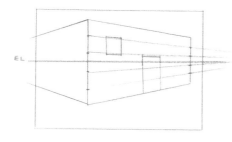

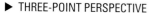

▲ When vanishing points are off the page, it can help to use a grid system like this in order to place doors and windows correctly. Begin by dividing the main vertical into an even number of divisions.

Then divide the remaining vertical (or the side of your paper if there is no vertical to use) into an equal number of divisions. Joining up these divisions will give you accurate perspective lines.

▲ ARCHWAYS

These can cause problems. Construct a rectangle around the archway, checking the proportion of width to height. Then find the perspective centre of the rectangle. The top of the curve of the archway will coincide with the perspective centre of the rectangle.

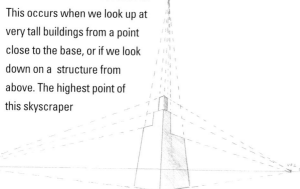

▶ THREE-POINT PERSPECTIVE

This occurs when we look up at very tall buildings from a point close to the base, or if we look down on a structure from above. The highest point of this skyscraper

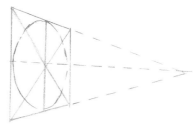

▲ CIRCULAR FORMS

To draw a circular form of any kind in perspective – for example, a pond, a wheel, a table-top, a circular window – begin by constructing a square in perspective (checking those proportions!). Find the central point by adding in the construction lines and then draw the circle.

is seen from below, creating a third vanishing point where the lines forming the sides of the building meet. In both two- and three-point perspective, the vanishing points shouldn't be placed too close together, as this will cause distortions within the image.

PROJECT
UNDERSTANDING PERSPECTIVE

Paper
Large sheet of white cartridge paper, or card

Equipment
At least ten magazine or newspaper cuttings
Glue
Felt-tip pen
Ruler
White or coloured boxes, ideally with one square side
Coloured pencils or paints

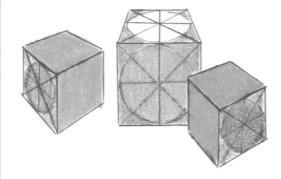

◄ If you extend the edges of these boxes, you will discover that they meet at different vanishing points on the eye-level, which is above the boxes. Remember that there will be two vanishing points for each box seen in two-point perspective.

Although these projects are simple and fun, they will nevertheless teach you a great deal about perspective – and may even surprise you too.

For the first project, find as many illustrations from magazines and newspapers as you can (at least ten), which offer examples of all the different elements of linear perspective. Choose a variety of subject matter, including street scenes, room interiors and landscapes. Cut them out and stick them onto a large sheet of white paper or card, leaving plenty of space around each illustration, in case perspective lines meet outside the image. With a ruler and felt-tip pen, find the perspective lines on each illustration; see if you can establish the vanishing point, or points, on the eye-level line.

For the second project, find, or construct, a simple box and paint a circle on one side. Draw the box in perspective with the circle in perspective, too. Measure proportions carefully if your box is not square. Draw an eye-level line, and extend your perspective lines to meet here.

▶ Practical exercises of this sort will certainly help you to understand perspective, and as you go about your daily life, you can develop your awareness further by looking hard at buildings or room interiors to find the eye-level and vanishing points in your mind's eye. This will help you to draw freehand with more confidence – it is best not to depend on a ruler too much or your drawings may look rather stiff.

SELF-ASSESSMENT

• *Did you clearly understand when one-, two- or three-point perspective applied?*

• *Do your perspective lines meet at a vanishing point, or points?*

COMPOSITION

When we look at figurative paintings, we are immediately aware of the subject matter. As beginners, our concentration focuses hard on how to make a tree look like a tree, or a cloud like a fluffy cloud. 'Well, of course,' I can hear some of you muttering, 'what else is painting about?'

Have you ever visited an amateur art exhibition and found yourself drawn like a magnet to certain paintings, despite the fact that they weren't obviously 'better' than any of the others? I would like to suggest that the paintings which commanded your attention were the ones which had been carefully designed, with the shapes, tones and colours organized in a balanced, harmonious way. This is called 'composition'. Good composition gives a picture a subtle underlying structure, which turns in into something more than a competently rendered 'shopping list' of, say, one stream, one bridge, six trees and lots of grass – all painted carefully 'because they were there'!

As you gain experience and confidence, you will learn to trust your intuition and to recognize instinctively when a

▼ *Majorcan Still Life with Grapes and Pears,* 28 x 55 cm (11 x 21¾ in)

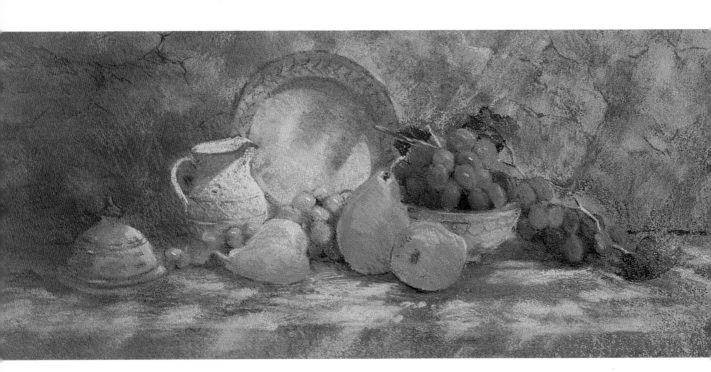

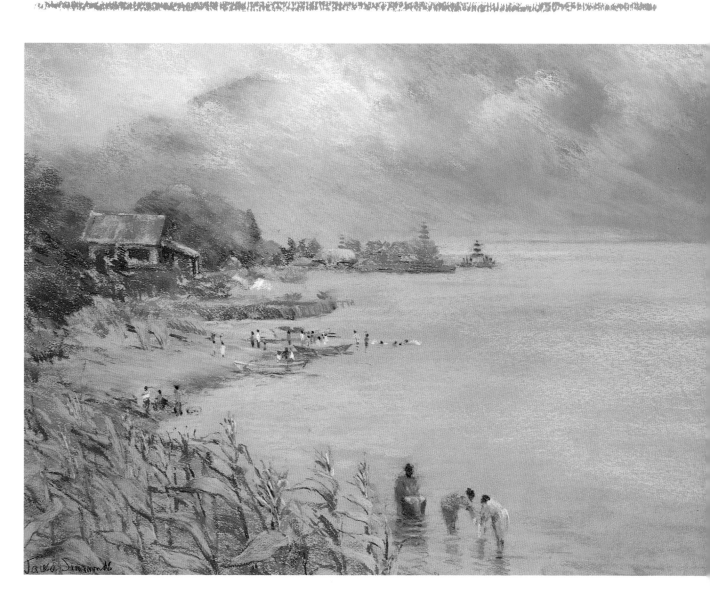

*The Shores of
Lake Bratan, Bali,*
45 x 61 cm
(18 x 24 in)

painting looks and feels right, even if it doesn't conform to any of the practical, traditional concepts that I am about to show you now. That is as it should be – there are no 'rules' in painting, only suggestions. We are all individuals, and our paintings should reflect our individuality. However, for now, you may find it useful to understand something of the basic concepts which have been used by many artists throughout the ages. Matisse once said, 'The whole effect of my painting depends on composition. The place occupied by figures and objects, the empty spaces around them, their proportions, each has its place.' Perhaps you could think of my basic concepts as 'foundation stones'. With good, solid foundation stones, we can build any kind of structure we like.

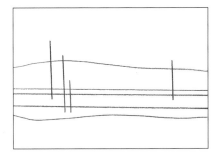

Horizontal and vertical lines and shapes echo the sides of the rectangle. They suggest an atmosphere of stability, calmness and strength.

Diagonal lines and shapes suggest activity – thrust, movement, excitement. They create a feeling of dynamic tension within an image.

Curving lines and shapes can create movement and energy, or can be quietly passive, depending on the activity of the line. Used excessively, however, without contrasting angular elements, they can diffuse energy, leading the eye out of the picture. An arc is a strong visual force drawing the eye inward toward its centre.

BASIC PRINCIPLES OF DESIGN

When we create a painting, we work on a two-dimensional surface. On this flat surface, we use painted symbols to suggest subject matter; these symbols can be fully developed and detailed, as in highly representational work, or simplified and abstracted. In all cases, their movement and direction can be designed to reinforce the expressiveness of the painting. For example, simple horizontal bands of colour could suggest a wide, sweeping landscape; strong diagonal movements could evoke trees in the wind or stormy seas; curving lines and shapes might convey the feminine form, rolling hills or moving water.

Although the little diagrams (above) are generalizations, they can be useful when we come to analyse what we want in a painting – and why it isn't happening! If, for instance, we want the painting to have a feeling of calm, and somehow the painting seems too active and lively, then perhaps there are too many diagonals and sharp angles. We can solve the problem by subduing the diagonal elements, emphasizing the horizontals and verticals.

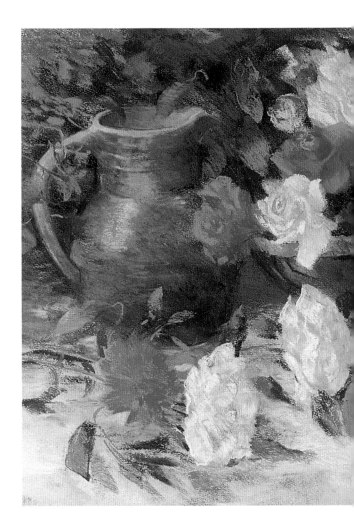

This image has unity. It has a visual rhythm, created by the repetition of certain shapes and lines – the simplest form of unity. In fact, repetition is one of the most valuable and widely used devices for achieving visual unity in a painting. However, I'm sure you recognize that because there is no variety in this image, it is rather boring.

Now we have related shapes, which echo each other and maintain the harmony and unity of the design, while at the same time providing variety and interest.

Finally, we add the element of contrast. Contrast will, by definition, emphasize the dominant qualities of the design. In this instance, the straight lines emphasize, by contrast, the curvilinear nature of the picture. Now we have a perfect balance of the elements of unity, variety and contrast. Simple, isn't it!

UNITY, VARIETY AND CONTRAST

A painting can be considered well-composed when all its individual elements look as if they belong together. They have 'unity'. Another term for the same idea is 'harmony'. This sounds straightforward, but I would like you to imagine a scrapbook page. Each item on the page is meant to be studied and appreciated separately. The items may have a common theme, but unity of theme will not guarantee a harmonious pattern – there may be no visual unity.

Unity in painting is often created by repetition. Colour is the simplest, most obvious element to repeat, but shapes, textures, directions and angles may also be repeated. However, we need to recognize that too unified a pattern can be monotonous, so, to prevent visual boredom, we combine unity with 'variety' and 'contrast'. Then our paintings will have an underlying compositional strength and rhythm. I hope my little diagrams (above) help to make this tricky subject clear for you.

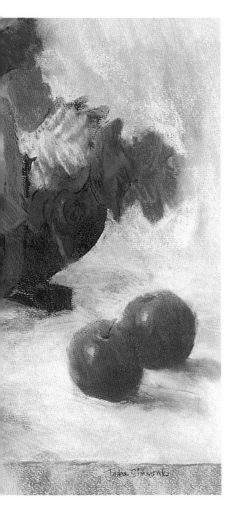

Red Apples,
45 x 58 cm
(18 x 23 in).
This painting largely depends on colour for impact, but the compositional rhythm of repeated curving forms reinforces the expressiveness of the image.

SHAPES

We have no problem with the concept of 'shapes' when we consider abstract paintings, which often rely on colour and shapes alone. It is more difficult to 'see' the shapes in a figurative painting, because we are seduced by the subject matter. It is important, however, to learn to look beyond the obvious and to recognize the interlocking arrangement of flat shapes on the two-dimensional surface. I recommend that you look hard at Degas' paintings, particularly his paintings of dancers. They are marvellously well-composed arrangements of echoing shapes and forms.

Translating subject matter into simple, interesting shapes, and combining these shapes to form an integrated design, with strengthen your paintings dramatically. In particular, joining shapes together will unify a painting – a group of trees, seen as a large, continuous shape, will have far more impact than six trees drawn individually.

HOW TO SEE SHAPES

When you look at your subject, the complexity of it can be overwhelming, be it still life or landscape. You should try to suspend, for a moment, your interest in the reality and detail of the subject, and try to think simply in terms of light and dark shapes and patterns. Squinting will help a lot! You need to practise this way of 'seeing' by making sketches in which you reduce the elements of your subject to the largest and simplest forms. You can make adjustments to the contours of the shapes in your design to ensure that they relate to each other, perhaps even repeat each other, in a pleasing, harmonious way. Try to forget about 'trees, shrubs and fields' and think instead of 'a dark curved shape of a group of trees, echoing the curve of a winding road', or 'the circular forms of the flowers echoed in the similar shapes of fruit and bowls, and contrasted with the vertical shape of a vase'.

As well as the specific shapes of objects, we need to be aware of the shapes created by the spaces between objects. These are called 'negative' shapes (objects are 'positive' shapes). Negative shapes are particularly important in still life painting, which we will look at later, but they occur in every type of subject – the shapes of the spaces between tree branches, boats or buildings, for instance. I would just ask you to try to remember that every painting is, in fact, a 'jigsaw puzzle' of interlocking shapes.

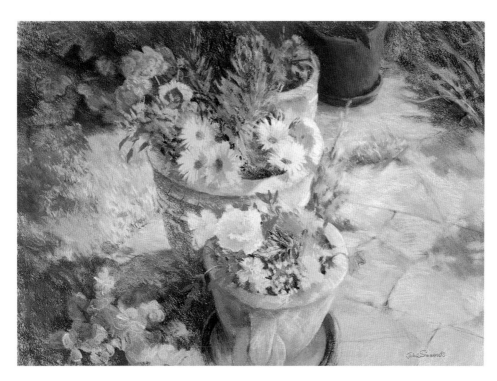

Patio Pots,
45 x 60 cm
(17¾ x 23½ in).
The curving forms of the pots are echoed in the shapes of the flowers and the subtle semicircles of lawn and patio.

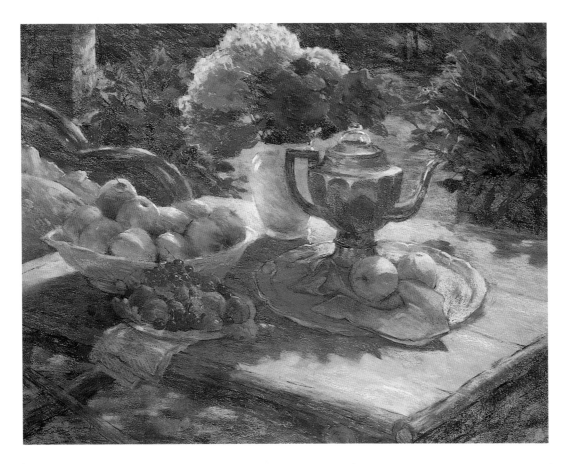

*The Silver Pot,
48 x 61 cm
(19 x 24 in).
The circular
shapes of the fruits
and flowers vary in
size. Cover the
plate of small fruits
– you will see
how important
they are for variety
and contrast.*

Here we have equal sizes and weights. They feel and look 'right'. Unfortunately, when we come to paint, this kind of formal balance doesn't seem to work too well. Things of exactly equal shape, distance or appearance have a tendency to appear monotonous.

A more dynamic kind of balance is achieved by creating an asymmetrical composition. When the shapes in your picture contrast in weight and size in this way, they will have far more visual impact.

BALANCE

One of the many things that will certainly help to create a good composition in a painting is the right kind of balance between the light and dark shapes, and between the large and small ones. My little diagrams (above) demonstrate this principle at work.

PRACTICAL TIP

If you have difficulty in 'seeing' shapes, try looking at the painting from a different perspective. Turn it sideways or upside down, for instance!

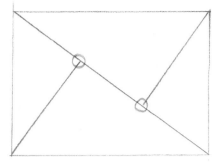

The diagram at the top shows two possible focal areas, each created by drawing a line from corner to corner of the rectangle, and then drawing another line at right angles from the opposite corner. Where the lines intersect is the focal area.

In the diagram above, we have four possible focal areas. In each case, the focal point would come approximately one-third of the way in from the side of the rectangle, and one third of the way down from the top or up from the bottom.

CREATING A FOCAL POINT

Usually, when we look at a painting, our eye travels around the image and finally comes to rest at the 'centre of interest' or 'focal point'. 'Centre of interest' is a slightly misleading term – it emphasizes the word 'centre', and this is what many a beginner immediately decides it means. After all, if someone handed you a bowl of flowers and asked you to put in on a table, where would you put it? In the middle, I suspect. However, when we are painting, if we ensure that the centre of interest in our picture coincides with one of the rectangle's official focal points, the result will be much more exciting. There are many ways of finding the focal points of a rectangle, some of them based on highly complex formulae, but I offer you two simple methods.

Having decided upon the position of your centre of interest, you can employ several different ways of attracting the viewer's attention to it. The eye will automatically be drawn to the strongest contrasts of colour, and of tone (light and dark), and also to the most intense areas of detail or textural interest.

There need not be just one focal point in a painting, but it may be best to have only one dominant one. Remember that when everything is emphasized, nothing is emphasized in the end, and confusion replaces interest. Finally, it is a good idea to make sure that your centre of interest remains part of the overall design and doesn't stand out as an alien element screaming for sole attention!

COUNTERCHANGE

I urge you to remind yourself repeatedly of the phrase 'light against dark, dark against light'. Sometimes, when we look at a subject, we are offered the opportunity to use counterchange straight away. For example, we may be immediately attracted to bright, white flowers surrounded by an area of dark foliage, and in the same scene, we notice dark trees silhouetted against a light sky.

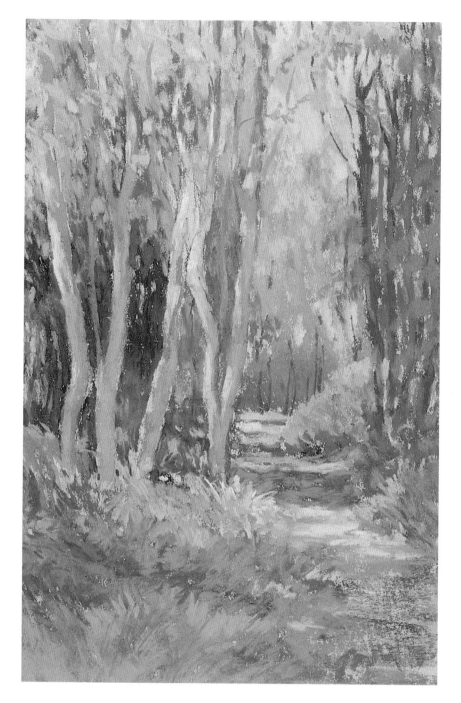

Woodland Path,
20 x 30 cm (8 x 11¾ in),
pastel on glasspaper.
Notice the use of
counterchange in this small
pastel. The large focal group of
trees, with pale trunks against
dark foliage, contrasts subtly
with the dark trees on the right
of the path, silhouetted against
the light.

Give yourself permission to adjust nature to
make use of counterchange in a very positive way,
particularly to emphasize your centre of interest if
you wish. For instance, by ensuring that the
darkest dark area in your picture is next to the
lightest light area, the viewer's eye will be
automatically drawn to this lively area of visual
contrast. Don't be afraid to use counterchange
elsewhere in your picture – just remember to use
it subtly, so that it will not weaken the impact of
your focal point.

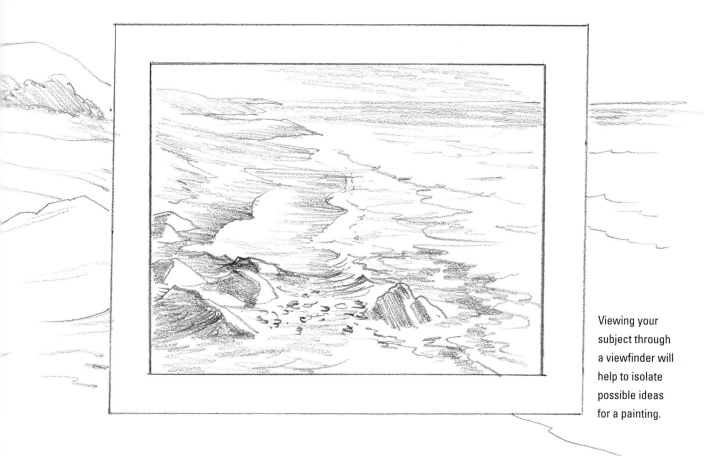

Viewing your subject through a viewfinder will help to isolate possible ideas for a painting.

USING A VIEWFINDER

Whatever your choice of subject matter, an invaluable aid to selection is a viewfinder, which can be made quite simply by cutting a rectangle of card measuring about 10 x 15 cm (4 x 6 in), with a central 'window' measuring 5 x 7.5 cm (2 x 3 in). This simple device will help you to isolate a particular section of a scene, and the edges of the viewfinder will act as a kind of picture frame. By moving just a little to the left or the right, you will be amazed to discover many more potential paintings in one scene than you had first imagined. An adjustable viewfinder – two L-shaped pieces of card which you can hold together with paperclips – is a good idea. In this way you can adjust the shape to suit your purpose.

You will discover that if you hold the viewfinder close to your eye, a large scene will appear, and the further away you hold the viewfinder, the smaller the scene. Notice where the horizon meets the edge of the 'window', and how high the trees are, for example. It may help you to mark your viewfinder so that you can transfer information more accurately. (Do make sure that your viewfinder has the same proportions as the paper you will eventually work on.) Squint as you look through the 'window'. This will help you to see the arrangement of light and dark shapes more effectively, and as you look, try to imagine the finished painting. In this way, you will begin with a very clear idea of what you want to achieve – an excellent way to start!

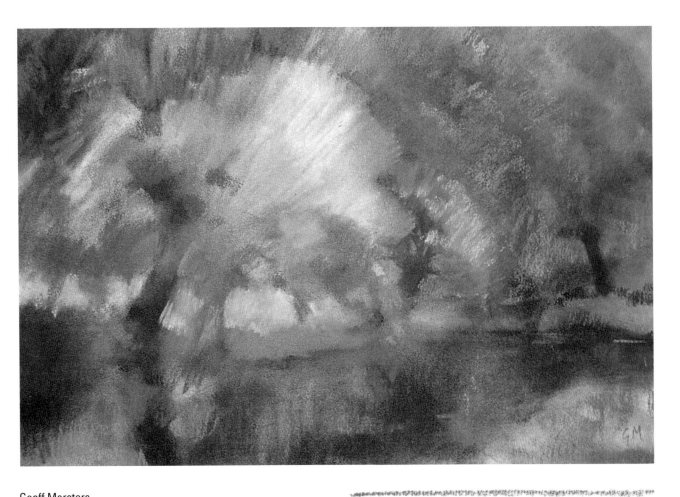

Geoff Marsters,
Cotswold Stream,
66 x 48 cm (26 x 19 in).
The artist has simplified and
emphasized the dramatic light
and dark elements of the
scene. A viewfinder might
well have been used to help
select the subject.

EXERCISES

1 Try to draw a chair by drawing only the negative shapes, in
other words the shapes you can see between the legs and
bars. Consciously avoid drawing the chair itself. This is the
best way to teach yourself to see negative shapes. If a chair
doesn't appeal, use a plant and draw the shapes between
the leaves.

2 Using your viewfinder, make a series of thumbnail
sketches. The subject matter isn't important – it could be
the corner of a room, the top of a table, an area of landscape,
a local park or even your garden. Combine and simplify
shapes, and consciously avoid details. Feel free to shift
things around to improve the composition – you can
even move trees to left or right! Your sole aim is
good composition.

PROJECT
EXPLORING COMPOSITION

Medium
Graphite and coloured pencils

Equipment
Tracing paper
HB pencil
Three coloured pencils
Old Master reproductions,
ideally minimum
15 x 20 cm (6 x 8 in)

The main focal area, shown by a red X, is highlighted by the cool blue cushion set against a warm brown chair and next to a bright orange fruit. Red lines show curvilinear movements and directions in the composition.

Green and blue lines explore shapes which are echoed throughout the image to add to the picture's compositional structure.

Despite the fact that there are no absolute rules for composition, it is my belief that it is impossible to paint a good picture without taking composition into account. This building-up of the underlying structure of a painting is one of the most difficult concepts to grasp, but it will pay enormous dividends if you can manage to do so. Trying to analyse another artist's work in order to make your own discoveries about the picture-making process will develop your ability to see and sense pictorial composition.

The illustrations on these pages show an analysis of one of my paintings, *Blue Cushion*. Using any of the paintings in this book – or better still, if you have them, fairly large reproductions of work by Degas, Van Gogh, Vermeer, Gauguin or Bonnard – take some similar tracings of your own. The Masters will be your best teachers, as all of them used formal compositional structure in their work. If you use any of my paintings, please don't hesitate to be critical. I still have a lot to learn in this difficult area, I'm sure!

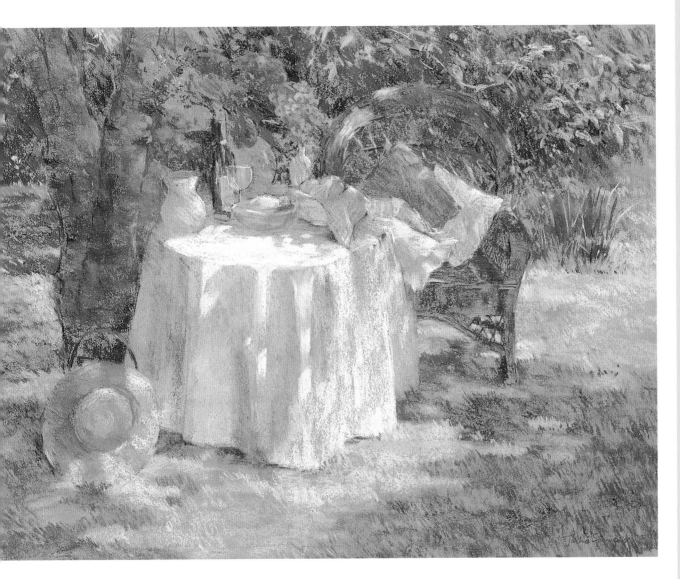

In your tracings, look specifically for:

- The focal point/area

- The main movements and directions (the underlying geometric structure) of the picture – horizontal, vertical, diagonal, curvilinear

- Echoing shapes

Blue Cushion,
45 x 60 cm
(17¾ x 23½ in).
The tracings analyse the underlying composition of the painting.

SKETCHING

Underlying every good painting is the ability to draw, and this ability can be acquired and refined by the regular use of a sketchbook. The more you practise, the better you will become – this is a fundamental, unarguable fact.

Sketching will increase your powers of observation. As you concentrate on your work, you will begin to appreciate what you see far more deeply. If you lack confidence, it will help to begin by drawing single objects. Draw wherever and whenever you can – every day ideally! As your confidence grows, your drawing will become stronger and have more authority. Your sketchbook can be a strictly private and personal 'visual diary' of places and things which interest you, and because you have taken the time to look long and hard at your subject, your sketches will conjure up more memories than a whole album of photographs!

▶ Norman Battershill, *Sky Study*, 15 x 22 cm (6 x 8¾ in)

▼ A sketchbook page showing Brawn Farm Fields.

USING A SKETCHBOOK

Sketchbooks are available in all sorts of shapes and sizes, from pocket notebooks to large pads. A good quality paper will take most media adequately, so you can work with graphite and charcoal pencils, coloured pencils, ink, felt-tip pens, biro, watercolour and even pastel. The choice of sketching tool is personal, but there are a few points to remember:

- Charcoal and pastel pencils will smudge and the drawings will need to be spray-fixed.

- Ink is permanent and won't allow for corrections – this isn't necessarily a disadvantage, as it concentrates the mind wonderfully.

- Watercolour needs to be completely dry before you close the sketchbook!

- Wax and oil pastels may stain through thin paper and spoil other sketches.

You should try to carry a sketchbook with you all the time and take every opportunity to use it. I always carry a very small pocket sketchbook – a hard-backed type rather than a spiral bound pad, since this allows me to work across a double-page spread if I want to. I've filled lots of these little books over the years, and browsing through them gives me great pleasure and many happy memories.

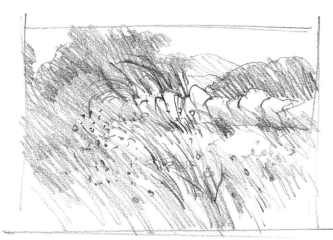

This thumbnail sketch for *Wild Flower Field* was drawn after selecting a small corner of the field through my viewfinder. It measures 5 x 7.5 cm (2 x 3 in).

Wild Flower Field,
45 x 60 cm (17¾ x 23½ in)

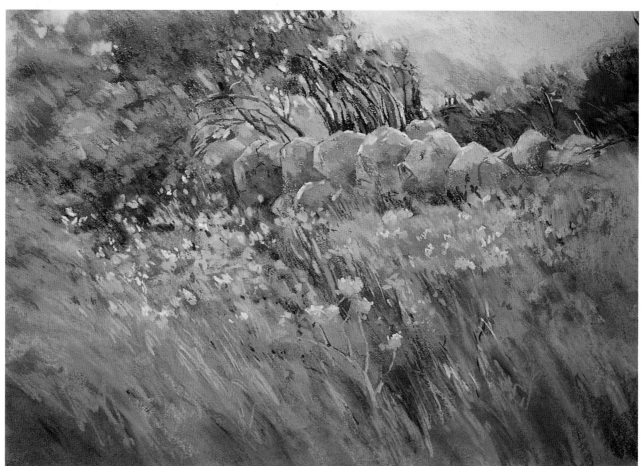

SKETCHING FOR PAINTING

Your sketchbook can serve a dual purpose. As well as using it for drawing practice and diary-type sketches, it can be used for preliminary drawings for paintings. These fall into two categories: the 'thumbnail sketch' which explores alternative ideas about composition, and the more detailed sketch, full of closely observed information which will ensure accuracy in later translation.

The thumbnail sketch is often used by the painter who intends to work from life. This is my preferred way of working; once I am happy with my thumbnail sketch, I feel more confident about embarking on a full-scale painting from life. However, this spontaneous approach does not suit everyone and there are artists who like to work from careful sketches and colour notes.

If this is your choice, you will need a great deal of visual information. You can use your

After establishing a grid over your sketch (using tracing paper if you prefer), draw a grid in the same proportions on your pastel paper or board. The image can now be easily transferred, using the grid lines as a helpful guide.

sketchbook to collect interesting details such as foliage or surface textures; the way a branch of a tree joins the trunk; the patterns in nature; the shapes of clouds, people or shadows. Remember that a line drawing, no matter how well observed, will tell you nothing about tone or colour, the direction of the light or the atmosphere of the scene. If you want to paint successfully from your sketches, you must include tone as well as line, comparing tones carefully as you work. You will also need good colour notes. 'Green' means little; 'palest green with a hint of yellow' says much more.

PRACTICAL TIP

Squaring-up by using a grid has one major disadvantage. A certain stiffness can creep into the transferred image, especially if every tiny detail and shape is transferred, which may encourage a 'painting-by-numbers' approach. Try to avoid this by transferring the largest shapes only.

SQUARING UP

You may decide that you like a sketch enough to want to use it for a painting. Sketches are usually smaller than finished pictures, and transferring information freehand often leads to errors of proportion, unless you are very careful indeed. You can avoid this problem by the use of a simple grid system. Ensure that your paper has the same proportions as your sketch.

CHOOSING A SUBJECT

As an artist, the world is your oyster. Almost anything can make an interesting subject for a painting. Some artists content themselves with painting the same subject over and over again; both Corot and Renoir painted the same subject matter and the same sorts of pictures all their lives. Other artists are remarkably versatile, switching from subject to subject, constantly exploring and experimenting.

The important thing is to choose what appeals to you, and what is familiar to you. I would advise beginners to remember the motto 'Keep it simple'. Pastels are an ideal medium for simplifying subject matter as they can be used broadly to capture the essentials of the subject. It isn't necessary to include every detail. Filter out fiddly details, leaving areas 'suggested' rather than laboriously painted in.

▶ *Pollença Market, Majorca,* 45 x 60 cm (17¾ x 23½ in)

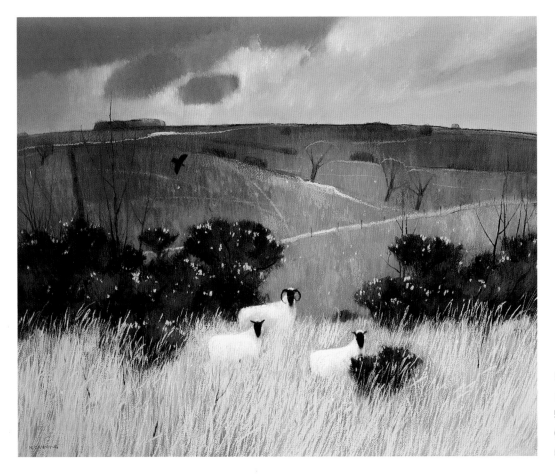

Neil Canning, *Sheep with Gorse,* 53 x 74 cm (21 x 29 in), mixed media

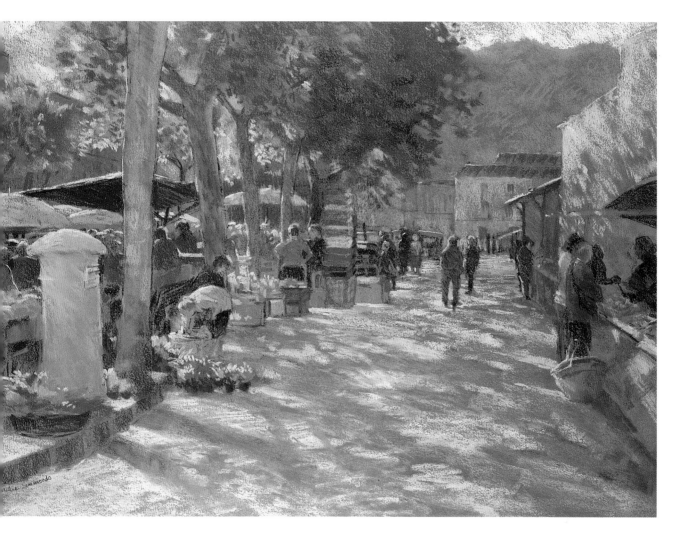

MAKING A CHOICE

Remember that the simplest subject can make a wonderful painting: a few rust-coloured flowerpots in a garden; some fat green–and–yellow pears; a dramatic skyscape. It is best to choose a subject within your capabilities. In this way, you will be encouraged by success, and you will gradually become bolder and more adventurous. As a student, I was encouraged to visit galleries and to study other artists' paintings. It surprised me to discover how many great artists painted extremely simple subjects. I learned a great deal from studying their work, and they gave me ideas for my own paintings.

It is particularly helpful to know not only what you like, but why you like it. Translated into painting terms, it may be the colour, the rhythm and movement, the relationship of shapes, the patterns, the effect of light, the feeling of distance, or the atmosphere which appeals to you. Any one of these qualities, and many others, could be said to be the 'inspiration' or 'idea' for a painting.

Margaret Glass,
Still Morning, River Deben,
38 x 56 cm (15 x 22 in),
glasspaper

▶ Richard Smith,
Lurs, Provence,
30 x 40 cm (11¾ x 15¾ in),
watercolour, gouache
and pastel

You may find it easier to recognize what interests and appeals to you than why. If so, it may help to spend a few moments in quiet contemplation before you begin. Perhaps you could write a few words or sentences in your sketchbook to describe what it is you like about your subject. It is surprising how a few simple words can help to focus your mind. If you find this difficult, then simply give your picture a title before you begin – this, too, will clarify your intention. If you refer back to your notes or think about your title as you work, you may find this useful as you make decisions about what to include, what to emphasize, what to subdue.

A common misconception about artists and painting is that the artist must 'be inspired'. This sounds as if inspiration is something which happens, and we must be patient and wait for it to occur – like waiting for the cavalry to come galloping to the rescue! In fact, the development of a painting is a gradual process, the result of concentrated effort, perseverance, and thought. To slightly mis-quote Thomas Edison: 'Painting is one per cent inspiration and ninety-nine per cent perspiration'! There are no short cuts to acquired skills. The more concentrated hard work you do, the more rewards you will reap in the form of 'inspired' paintings.

STILL LIFE

Still life painting offers many fascinating challenges to the artist. Almost anything can be interesting and exciting to paint, from a single shiny apple or a trio of fat onions to a more complex arrangement of fruit, flowers and vases.

The still life can provide a marvellous opportunity for experimentation with composition, texture, shape and colour relationships. Cézanne liked to rework his pictures, overpainting frequently; he organized colour to unify the design, and composed space so that the eye travelled around the picture surface. His subject matter was often simple – a few apples, a vase, some folded cloth – which proves that the subject matter of a painting is far less important than the artist's intention. A song can be beautiful with simple words; a painting can be wonderful with simple subject matter.

There are great advantages to painting still life. You select the objects, the lighting and the surroundings. You can move yourself or your objects around as you wish. Best of all, you can take your time in an atmosphere of quiet contemplation.

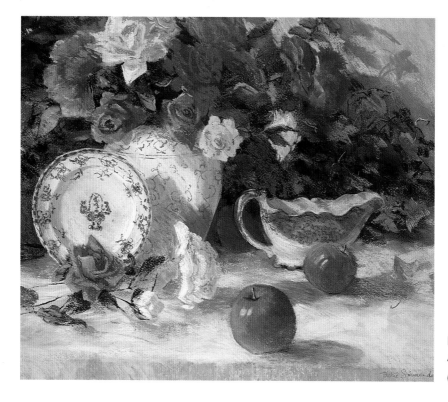

Red, White and Blue,
45 x 60 cm
(17¾ x 23½ in)

▶ *The Barn Table,*
45 x 60 cm
(17¾ x 23½ in)

WHAT TO CHOOSE

Still life subject matter is a question of personal choice. You may decide to paint a corner of your surroundings. A sofa with scatter cushions is a 'still life'; as are clothes hanging over a chair, articles in the garden shed – the list is practically endless! Walk around your home with a viewfinder. You will be surprised by the many 'ready-made' possibilities.

Alternatively, you can set up a still life. Some people feel that arranged still life set-ups look contrived; if this concerns you, then it is best to make sure that you select objects which look 'right' together. Old muddy boots might look fine together with things from the garden shed, but would look very odd indeed with china and lace! An extreme example, but it makes the point.

I like to choose objects for their shape and colour, and for the rhythms they create when grouped together. I browse around antique fairs and junk shops, and over the years I have acquired, at very little cost, wonderful plates, vases, baskets, oil lamps and tablecloths. I recently bought a beautiful old pink glass oil lamp. I love its colour and shape so much that I have used it in two paintings so far, and will no doubt use it again. I believe that if you surround yourself with visually exciting treats, you will never fail to find something interesting to paint.

You may be drawn to pattern or texture; to angular shapes; to reflections in shiny surfaces; to glass and its transparency. The important thing is to choose whatever you really like. If you are bored by your subject matter, you are likely to be bored by your painting.

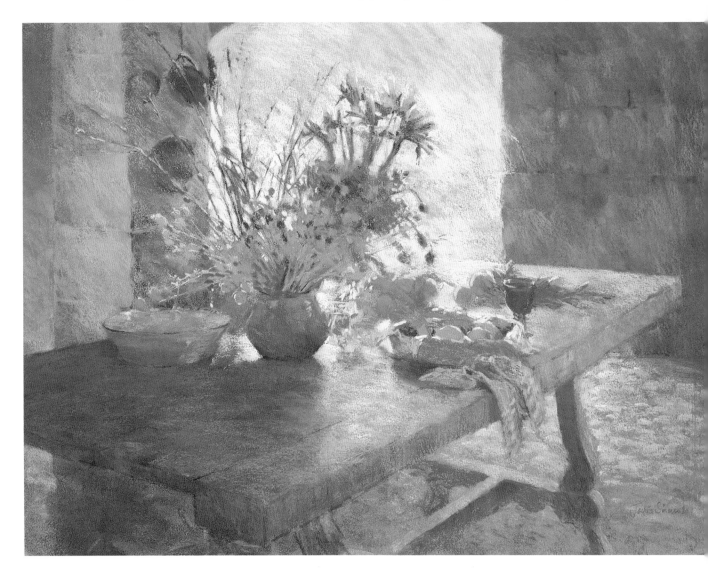

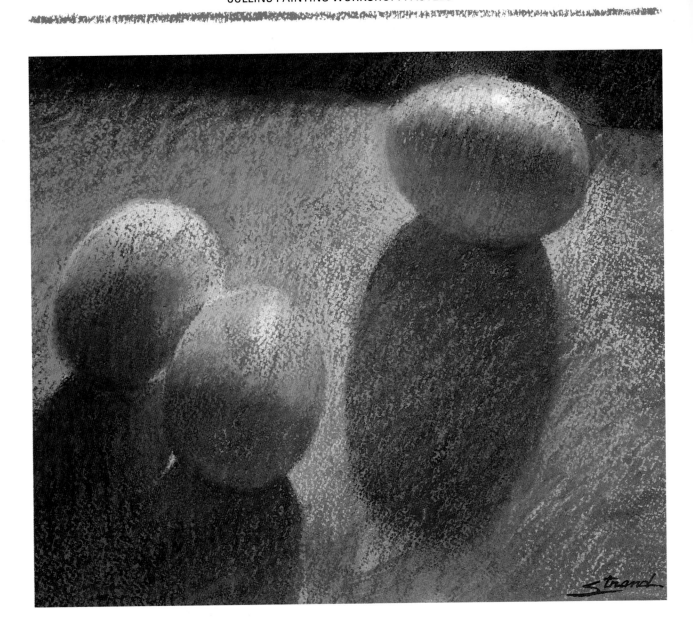

Sally Strand,
Three Eggs,
21 x 27 cm (8⅜ x 10⅝ in).
Sally Strand takes three
ordinary white eggs and
produces a very unusual
image of quiet and simple
beauty. Fascination with
the play of light is the key
in Sally's paintings, and
here the light flows over
the eggs, creating long
dramatic shadows and
colourful reflected lights,
which are painted with
closely woven strokes of
blues, purples and greens.

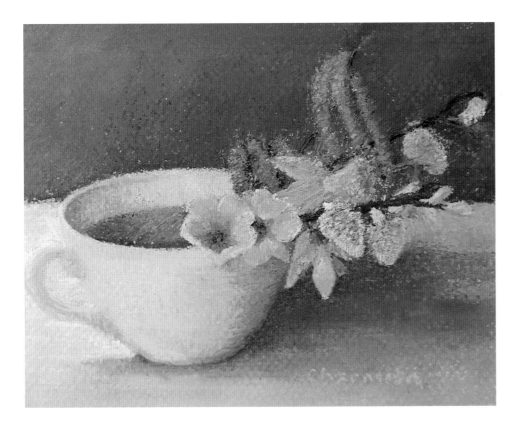

Charmian Edgerton,
February Cup,
27 x 30 cm (10¾ x 11¾ in).
A white cup and a few garden flowers; uncontrived and apparently simple. Look more closely and you will see how the artist has developed the image by painstakingly overlaying complementary colours, allowing flecks of each previous layer to show through. The final image is intense and beautifully observed, glowing with luminous colour.

COMPOSING A STILL LIFE

Having selected an interesting array of objects, ideally with fairly simple basic forms, and different shapes and sizes, you then have to put the articles together to arrive at a composition which is pleasing to the eye.

You can, of course, move things around freely, but sometimes the ideal composition can be arrived at by moving your position slightly. Take a careful look at the group from different positions. Some viewpoints will be obviously much better than others. Don't just settle for the predictable viewpoint – straight across at eye level. Look at your subject from right and left, and from slightly above. Begin to explore the possible compositions by looking through your viewfinder, and make several thumbnail sketches. In my opinion, these little exploratory sketches are essential to help you to begin to investigate tonal patterns, shapes, proportions and balance.

Mastering a simple still life of two or three objects will give you confidence to try more complicated arrangements eventually – if that is what appeals to you. Take things slowly to begin with. A still life can often present a great many unexpected problems. Areas which you anticipate will be easy often prove to be great big stumbling blocks, even for the experienced professional! You will need a great deal of the three P's – Patience, Perseverence and Practice! Here are a few compositional traps which are best avoided:

- DON'T have too much space at the bottom, top or sides of your still life

- DON'T leave an unoccupied space (a hole) near the centre of your painting

- DON'T scatter your objects around – try to ensure that they overlap

- DON'T put the table line horizontally across the centre of your picture

- DON'T place the subject so that it is sitting right on the base of your picture

- DON'T begin without thinking about the background – more about backgrounds later!

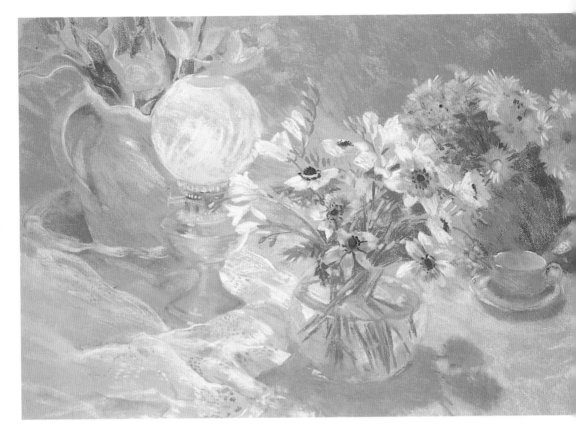

Still Life by Lamplight, 45 x 60 cm (17¾ x 23½ in). Original effects of light can be created by using unusual light sources such as candles or, as in this instance, an oil lamp. Warm golden light bathes a white tablecloth and a swathe of white lace fabric. Cool blue-grey paper provides a subtle complementary contrast for the shadow areas.

PRACTICAL TIP

When you need to draw a perfect oval such as the top of a cup or bowl where the distance from front to back is quite narrow, it helps to construct a rectangle around the oval first, measuring depth and width carefully. Divide this into four sections and make each quarter of your oval identical.

LIGHTING

It is important to decide upon the lighting of your arrangement. Remember that daylight from a window – enchanting though it may be, particularly when the sunlight streams in and magically illuminates the scene – will change according to the time and the weather! The easiest way to light your still life in an interesting way is to use an adjustable lamp or spotlight. Try it at different heights to see the different effects. Set quite high, it will give you short shadows, while a low light will give long, more dramatic shadows. Back-lighting will throw a beautiful halo of light around the objects, and sometimes even through them, causing flowers, for instance, to glow as if lit from within.

A secondary light source can provide a new challenge: an array of double shadows. The colours and shapes of shadows can be a fascinating study in themselves, and shadows serve another useful purpose – they often help to link an object with its neighbour, and with the surface upon which the object stands.

DRAWING YOUR STILL LIFE

No matter how beautiful the colour and how correct the tones in your picture, if the objects in your still life are poorly drawn, the picture will suffer. There are no short cuts, I'm afraid. The key to good drawing is practice, and then more practice. It's back to the three P's!

The rules of perspective that we looked at in Chapter 6 all apply to still life – a table top, a book or a box will all conform to the basic principles of one- or two-point perspective. If your drawings don't look quite right, use these rules to help you to make adjustments.

Still life arrangements often contain geometric forms which need to be correctly drawn, taking perspective into account. Circular forms are particularly common and seem to cause beginners no end of problems. Straightforward circular forms such as apples or oranges aren't too difficult. However, circles which appear as ellipses when they are seen at an angle, like the top or bottom of

a glass, a cup or a bowl, a circular tray or a plate – these can be difficult to render accurately. If you find ellipses, or circles, difficult to draw freehand, first plot the outline with some lightly drawn dots; you can then join the dots to form a perfect shape.

EXERCISE

Take a glass and see how ellipses change according to your viewpoint. Place the glass on a table in front of you and sit so that the lip of the glass is level with your eyes. It will appear as a straight line, while the bottom of the glass appears to curve slightly. Now stand up and look down on the glass. The top opening will appear almost circular.

Lift the glass and hold it above your head. Notice how the curve of the bottom of the glass is *less* than the lip of the glass.

◄ This diagram helps to explain 'ellipses in perspective', and using this knowledge will improve your drawing dramatically. The centre line is an ellipse seen at eye level. Above and below the eye level, the curves of the ellipses gradually increase.

◄ Look carefully at the ellipse which forms the base of this glass; beginners often draw base lines as flat horizontals. The top of the glass has been constructed using a simple rectangle divided into four.

*Study in Pink,
45 x 60 cm
(17¾ x 23½ in).
The diagram
shows how an
imaginary grid
could be used to
plot positions of
objects.*

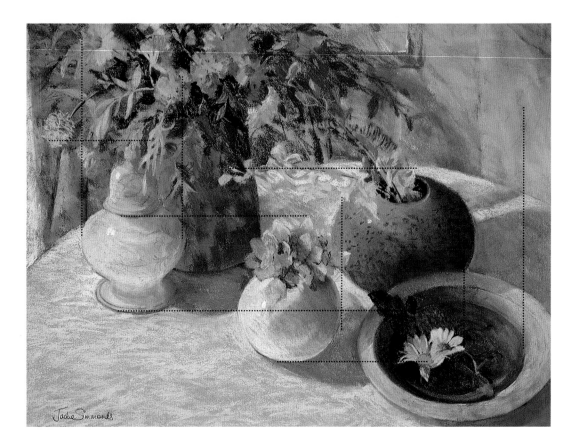

PRACTICAL TIP

*If you are very much a beginner, and worried
about this business of 'designing' your
background shapes, simply take a fairly close
view of your still life, allowing it to fill a large
proportion of the rectangle. This will solve a
great many problems automatically.*

RELATING OBJECTS

As a student, I was taught to relate an object to its
surroundings by drawing a figure seated in front of a
grid drawn on white board. I drew a grid on my
paper and then plotted the outline of the figure
exactly in relation to the grid. This produced a rather
stiff, but very accurate drawing.

If you set up a still life against a natural grid of
verticals and horizontals such as table edges,
window frames and pictures on the wall, you can
plot these horizontals and verticals lightly on your
paper, and see where your subject intersects the
lines. Relating one object to another in this way
will help you to achieve more accurate proportion
and placing.

Without the benefit of any ready-made
horizontals and verticals, you can construct an
imaginary grid in your mind. Simply use your eyes,
an outstretched pencil or even a plumb line to
check across and down your subject in order to
relate one object to another and plot its position.
This may feel a little strange – like using a new
muscle that you didn't know you had –
because we are so used to looking around the
contours of objects.

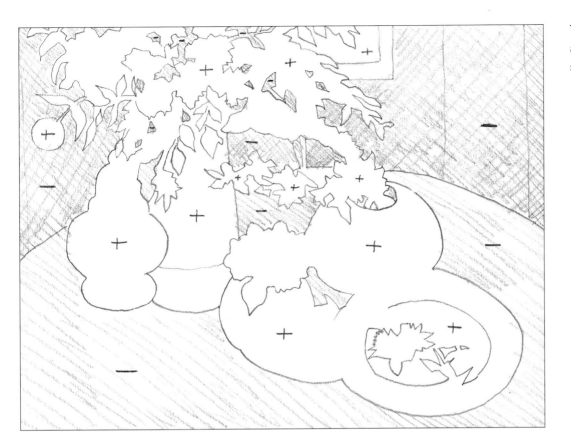

The shaded areas are 'negative' shapes.

NEGATIVE SHAPES

When we begin to draw or paint a still life, our attention focuses naturally on the subject – the objects themselves. These objects are called 'positive' shapes. The 'negative' shapes – the spaces between and around the objects – are often given little attention and tend to be left until last (as in the case of the 'background'). These negative spaces, however, are just as important as the subject. A painting always contains interlocking positive and negative shapes, just like a jigsaw puzzle.

Negative shapes serve two useful purposes. Often, despite much concentration, effort and redrawing, your objects just don't look right. This can sometimes be because you have drawn what you think you see, rather than what is actually there. If you leave the objects alone for a while and concentrate on drawing the shapes between the objects very carefully, I guarantee that you will be surprised to discover how quickly you can correct inaccurate drawing.

The second reason for learning to recognize the importance of negative shape areas in a picture is that a well-designed composition takes account of *every* area in the picture. Carefully considered negative areas in a painting will enhance the positive elements, and your design will be more forceful as a result. The dreaded word 'background' springs immediately to mind here – a background area which is basically unplanned will inevitably look as though it is an afterthought. I encourage you to look at the great Masters. Cézanne, for instance, often had quite large negative 'background' areas in his paintings. He made them interesting by using a variety of colours which both echoed and harmonized beautifully with the main colours of the subject.

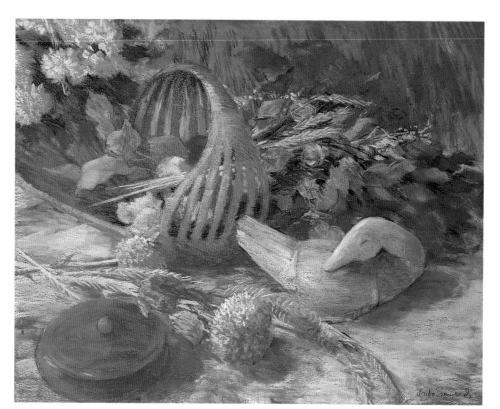

*Straw Duck and
Dried Flowers,*
45 x 57 cm (17¾ x 22½ in).
The edges of the straw duck
are clearly defined, while the
leaves behind soften into their
surroundings. Also, although it
is possible to discern some
individual leaves, they are
largely massed together to
create a darker-toned area.

MASSING FORMS AND MASTERING EDGES

Because a still life is usually very close to you,
there is a tendency to see and deal with each
object separately. My advice here is to half-close
your eyes, in order to reduce colour and detail.
The balance of your composition will be
dramatically improved if you mass forms
together in the light and dark areas, rather than
simply paint the light and dark parts of each
individual object.

Every object has an edge, or boundary, and
space and form can be emphasized or subdued
by learning to differentiate between 'hard' and
'soft' edges – sometimes called 'lost' and 'found'
edges. A crisp, hard edge, particularly one which is
light against dark, will be sharply in focus and
will attract attention. If you give every edge
within your picture equal importance in this
way, the result will have a rather hard,
photographic quality.

Where a form is further away in space, moves
away from the light or is very close in tone to its
neighbour, its edges will be soft, even hazy and
indistinct. Paying close attention to these subtle
nuances will pay great dividends – look at the
Masters for inspiration and information.

PRACTICAL TIP

*If you use cut flowers, open the ends of the stems
to allow the flowers to absorb plenty of water –
perhaps even add an aspirin to the water to
prolong their life. Some say that lemonade, instead
of water, will ensure longer life for cut flowers!*

▶ Mary Hackney,
Victorian Vase,
45 x 60 cm (17¾ x 23½ in).
The left-hand side of the white
vase is a 'found' edge, light
against dark, drawing the eye
up and around the blooms in
the vase. Some of these are
clearly defined, while others,
such as the white blossoms at
the back, have softly blended
edges which melt into
the background.

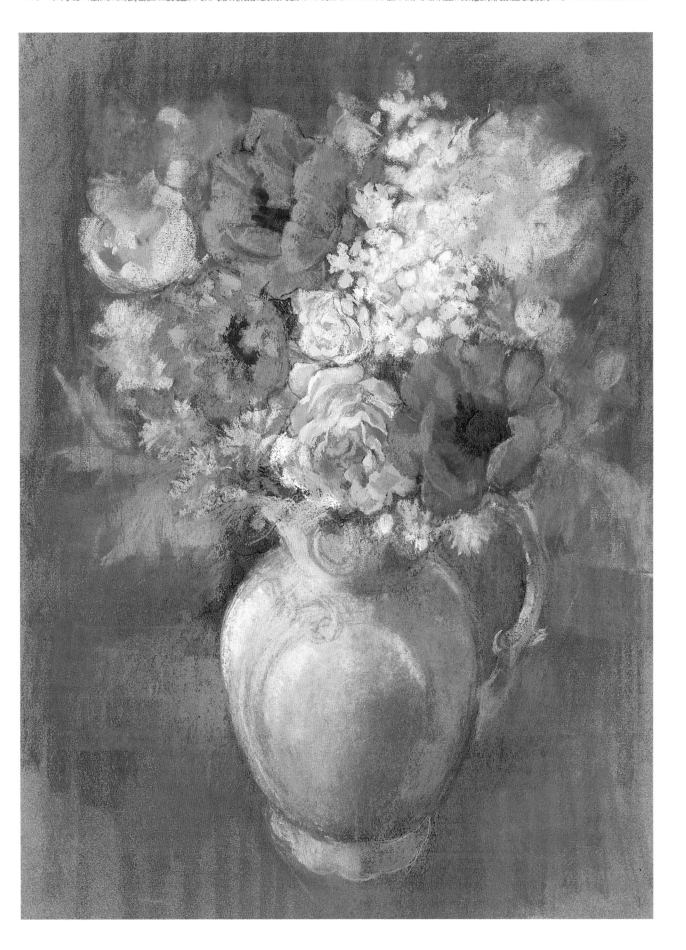

◀ Pip Carpenter,
Table in the Sun,
76 x 58 cm (30 x 22¾ in).
Pip is fascinated by the
rhythms and patterns in nature,
and the puzzles of illusion. In
this exciting image she
explores not only the pattern
of the wrought-iron table itself,
but also the patterns
created by the shadows falling
on and through the table onto
the ground.

▶ Jenny Webb,
*Poinsettia and
Maggie's Scarf,*
45 x 61 cm (18 x 24 in).
Plant and background fabric
lock together in a dancing
jigsaw puzzle of echoing
shapes, but the artist cleverly
allows the viewer's eye to 'rest'
on the table surface before
exploring the little patterned
ornaments. Rest areas like
these are important in a very
busy, active painting.

PAINTING PATTERN

Decorative pattern plays a major role in our daily lives. We can find applied pattern everywhere, on curtains, tablecloths, cushions, wallcoverings, fabrics, rugs, china. Some pattern is an integral part of an object's surface appearance – for instance, woodgrain, hessian, basketweave and marble all have different natural patterns. If pattern interests you, and you would like to include lots of patterned areas in a still life, there are some aspects of painting pattern that you need to consider, if your painting is to be successful.

If you want your picture to give the illusion of three-dimensional form together with pattern, then it is important to ensure that you 'tie' the pattern to the form – form first, pattern on top, as it were. Alternatively, an effective way to demonstrate that pattern is your primary interest is to emphasize it and give it full impact by flattening form completely, reducing your objects to simple shapes or outlines which are then filled with blocks of pattern. If you decide to try this, do remember two of the important aspects of composition – balance and contrast. You will need some solid, quiet areas in your picture to offset the gaily patterned ones.

PROJECT
STILL LIFE OF BREAD AND ROLLS

Medium
Chalk pastels

Colours
A selection of your choice to include white, pale cream, ochre, raw sienna, medium ochre, burnt sienna, warm dark brown, medium bluish-violet

Paper
Blue-grey pastel paper

Size
Minimum 30 x 40 cm
(12 x 16 in)

The paintings on these pages show that a still life does not need to be complicated. Everyday objects can make suitable subjects and give you practice with composition, tone, colour and texture. My study of a loaf and rolls uses a limited palette and is a simple subject, but nevertheless it is full of interest.

Using several different shapes of bread and rolls (they do not have to be the same as mine), arrange them on a table-top in a pleasing way, ideally lit from one side only. Make sure they overlap in places. Begin by producing one or two thumbnail sketches to decide upon a suitable composition. If you are a beginner, do not worry too much about absolute accuracy in the shapes of your breads. Concentrate more on accurately representing tone and colour, and establishing the basic forms.

Breads,
30 x 52 cm (11¾ x 20½ in).
Look at all the different tones and colours in the warm brown crusts, and notice how the round forms have been emphasized by occasional marks which follow the contours of the breads. The paper colour – a cool, soft, blue-grey – was chosen to contrast with the warm earth colours of the breads.

▶ Joan Wilmoth,
Straw Hats,
46 x 35 cm (18¾ x 13¾ in).
Old straw hats, piled high and painted boldly with lively cross-hatched strokes of soft pastel. Sunlight bounces off their yellow and gold surfaces and creates vivid complementary purple shadows; the artist repeats these colours, in deeper tones, in the simple background.

Joan Wilmoth,
Apples on a Plate,
21 x 27 cm (8¼ x 10¾ in).
You need not search far for inspiration, as Joan shows us with the jolly little still life of apples and apple pieces. Apples are fun, and good practice, to tackle – you have to consider shape and volume as well as surface colour and texture. New shapes, surfaces and textures can be created quite simply by cutting or peeling fruit.

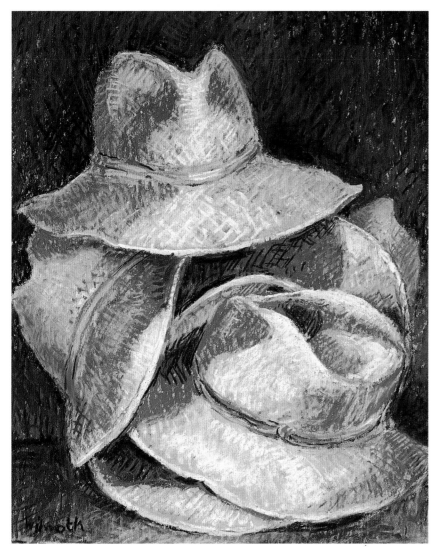

SELF-ASSESSMENT

- *Do your objects sit properly on the surface or do they float above it?*

- *Did you think about tones as well as colour?*

- *Did you look at proportions? And each object's position in relation to its neighbour?*

- *What about the composition? Is your group balanced? Too central? Falling out of the bottom? Floating in a sea of space?*

- *Did you use colour for your shadows, or grey?*

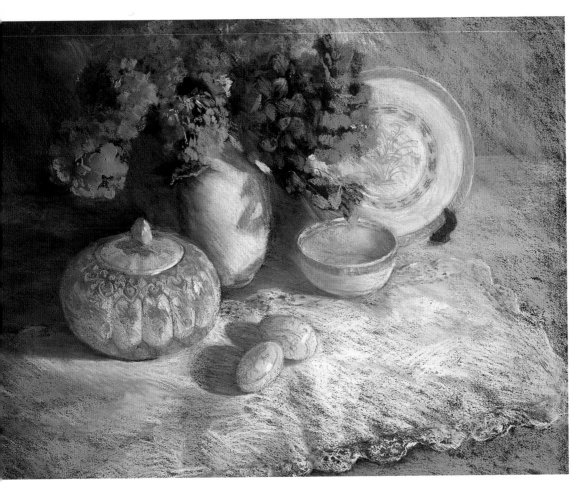

*Hydrangeas,
China and
Decorated Eggs,
45 x 60 cm
(18 x 24 in)*

FLOWERS IN STILL LIFE

Flowers have inspired artists throughout the ages; their wonderful colours and shapes offer absorbing painting subjects, no matter whether you paint a single tulip or an array of jars and vases overflowing with luxuriant blooms. Although it is lovely to see and paint flowers in their natural environment, painting cut flowers, or plants, as part of a still life gives you the opportunity to compose your own arrangement, and to study shapes, forms and colours in privacy and peace.

INITIAL OBSERVATION

In order to paint flowers convincingly, you need to understand and be able to draw their basic forms and structures. In a sketchbook, practise drawing plants and flowers. It doesn't matter if your results aren't marvellous – the important thing is to be looking hard, exploring leaf shapes, petals, stems. In your studies observe how leaf stalks join the main stem of the plant; investigate how petals grow from the centre; see how the shape of a flower head alters according to your viewpoint. If a stalk disappears behind a petal or leaf in your drawing, make sure it reappears in the right place! See how light affects colours – white flowers, for instance, may be blue, green or violet in the shadow areas, and pink or cream in sunlight or artificial light. See if you can learn to capture, with a few economical strokes, a flower's essential characteristics.

PAINTING FLOWERS

Flowers have a limited lifespan, so it is essential to work quickly. Planted flowers in pots will last longer than cut flowers – useful for the inexperienced painter. Flowers move all the time, turning their heads to the light, and opening or closing according to the time of day; buds develop into flowers overnight, leaves and stalks twist and turn. You need a flexible approach! On the facing page are a few suggestions to help along the way:

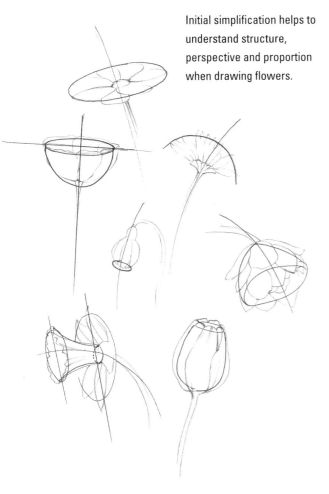

Initial simplification helps to understand structure, perspective and proportion when drawing flowers.

- Remember that flowers are fragile and transitory. Don't overwork your paintings in an attempt to capture a photographic likeness. By labouring too intensely, the result maybe lifeless, wooden flowers.

- Try not to paint each flower separately. When we look at a group of flowers, what we really see is blooms and foliage merging in places, creating colour masses. Only certain blooms will be sharply defined, reflecting bright light and colour; their edges will be crisper 'found' edges while flowers at the back, or in shadow, will soften into their surroundings.

- Try to ensure that flower blooms overlap each other, and arrange them so that they offer different views, not just front facing, but also profile, and even back views, to add interest. Try not to arrange them too symmetrically or they may look rather stiff and formal.

- Be mindful of colour. Simple colour harmonies are often far more effective than garish multicolour arrangements.

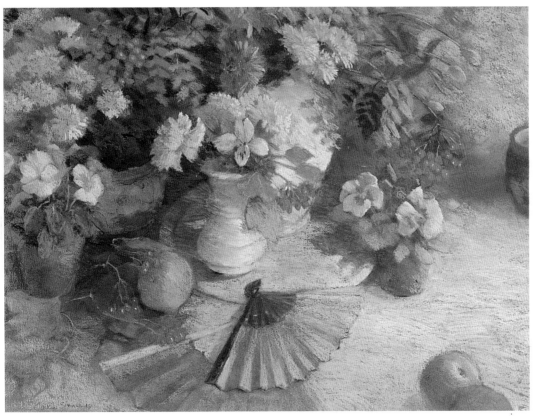

Fans and Flowers,
45 x 60 cm
(17¾ x 23½ in)

Hydrangeas, Apples and Grapes

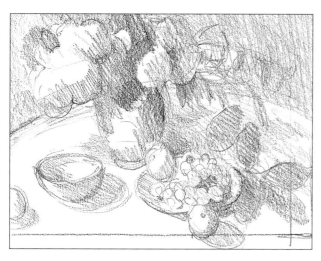

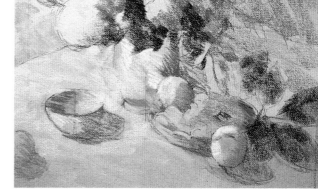

▲ STEP 1

The still arrangement was harmonious in colour and the grapes echoed the shapes of the flower heads. Using a viewfinder to select a composition, I produced a small sketch which analysed compositional structure and distribution of tones.

▼ STEP 2

I drew the main elements of the composition on grey Canson paper, carefully constructing the shapes of the bowls and the vase. Notice the vertical and horizontal lines which help with the structure and placement. These charcoal lines can easily be brushed off.

▲ STEP 3

I fixed the drawing and then roughed in the main dark and light areas, using the sides of my pastels, allowing the colour to drift across the drawing. So as not to overload the paper, I kept my touch light. I used warm, dark colours in the shaded foliage – these warm darks recede.

▼ STEP 4

I then began to graduate tones to show how the light described the three-dimensional forms of the flowers, fruit and bowls. Notice how I worked across the whole image; if you isolate and complete one section at a time, it is hard to judge tones accurately.

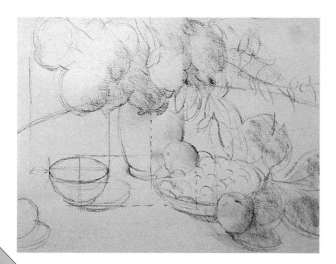

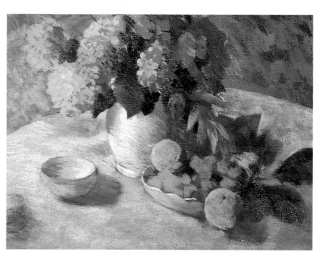

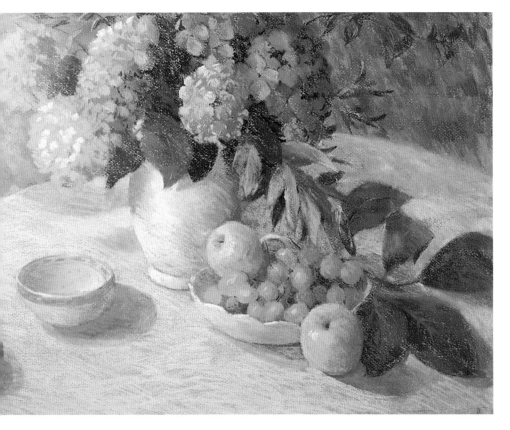

◄ STEP 5

Having established basic shapes, I started to define the flowers, picking out the occasional light and dark edge or shape, and softening in places with my finger where tones merged. I overpainted the leaves that were lit by the electric light with a warmer green, and I used creams on the white table-top and white china. Soft greys and purples were used in the background to repeat and harmonize with the flower and shadow colours.I continued to work steadily across the whole image, bringing the painting to a conclusion. Brilliant yellow on the apples acted as a good complementary colour contrast to all the purples. I adjusted tones carefully, and redrew in places; for example, the leaves on the table drooped a little and I rather liked the new shapes. For a little more drama I darkened the background on the right. I then added some final dark touches to the foliage and highlights to the apples and grapes.

▲ DETAIL

I have not defined every single petal of the flower heads, as this detail shows, but I believe there is enough information for the image to 'read' coherently.

COLOURS USED INCLUDED:

Cream
Yellow gold
Light ultramarine blue
Blue-violets – light,
medium and dark
Warm and cool greens
Dark burnt sienna

PROJECT

STILL LIFE WITH FLOWERS

Medium
Pastel

Colours
This depends on the flowers and fruits selected. Make sure you have a good range in light, medium and dark tones

Paper
Pastel paper or board

Size
Full sheet, approximately 45 x 55 cm (17¾ x 21¾ in), or half sheet

Equipment
Tissues
Charcoal
Fixative
Flowers or plants in suitable containers
One or two other items, including fruits

The planning of a still life group which contains both natural forms (flowers, plants and fruits) and geometric shapes (vases, plant pots and bowls) is certainly not easy, but it will give you the opportunity to practise everything you have learned so far. Beginners should tackle no more than two or three items at the most. Two plants in pots, plus a piece of fruit of a suitable colour, will present all the same problems of drawing, composition, tone and colour. More experienced painters could launch into the challenge of a larger grouping. Ideally, keep the colour scheme simple; if you are worried about colour and not sure where to begin, you could use one of the colour schemes shown on these pages or even borrow a colour scheme from one of the Masters.

▶ *China Blue,*
45 x 60 cm (17¾ x 23½ in).
The patterned decoration on the china follows the form; the shapes were established first and pattern added. If you define patterns too sharply, and with incorrect tones, they may appear to hover above the object.

▼ Charmian Edgerton,
Wild Flowers and Spoons,
30 x 38 cm (11¾ x 15 in).
Instead of being formally arranged, these wild flowers seem to have been popped into the nearest convenient container. The warm colour scheme of yellows and oranges is offset by complementary blues and purples, and despite the brighter colours in the image, the tonal key is subdued, creating a quiet harmony.

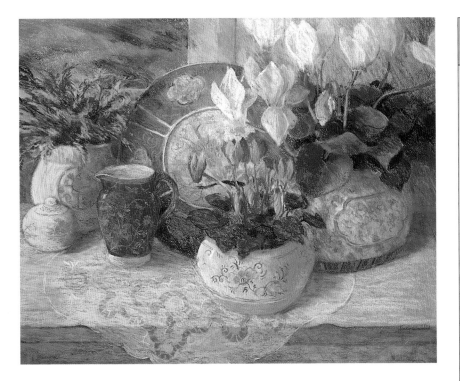

In this exercise, you need to be primarily concerned with colour, light and form. Select flowers and fruits which relate harmoniously to each other in colour and echo each other in form. Use a single light source, ideally one which will remain constant for some time. Plants will live longer than cut flowers, so if you work very slowly, this is a consideration. Dried flowes will last indefinitely! Your viewfinder will help you select a suitable composition. You may decide, in the end, to tackle only a small section of the whole. Use this project to develop your analytical abilityas well as painting skills.

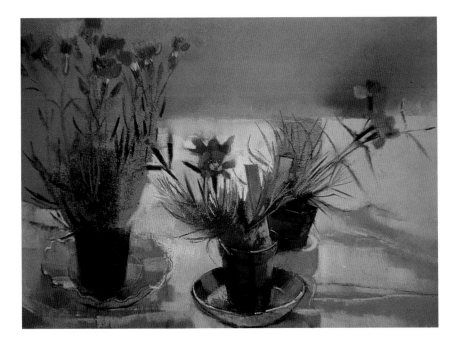

Claire Spencer,
Pinks by the Studio Window,
58 x 83 cm (22¾ x 32½ in).
Claire uses broad areas of flat, velvety, blended colour which contrast with the stiff, spiky linear drawing of the foliage. The colours are sometimes contained within the form and sometimes allowed to drift out of and around forms, linking them subtly to their surroundings. The artist shows how a more adventurous approach can produce an unusual and very exciting image.

GARDENS: INTIMATE LANDSCAPES

Working out-of-doors presents the artist with a huge new challenge. You will often have to cope with drastic weather changes; insects and other creatures; cars and lorries which appear from nowhere and park right in front of you; and worst of all, curious onlookers, some of whom will inevitably offer 'advice' – when they are not making derogatory remarks in stage whispers! Beware, too, of sticky-fingered, interested children; I've lost lots of pastels to angel-faced cherubs!

Claire Spencer,
Iris Garden,
58 x 83 cm
(22¾ x 32¾ in)

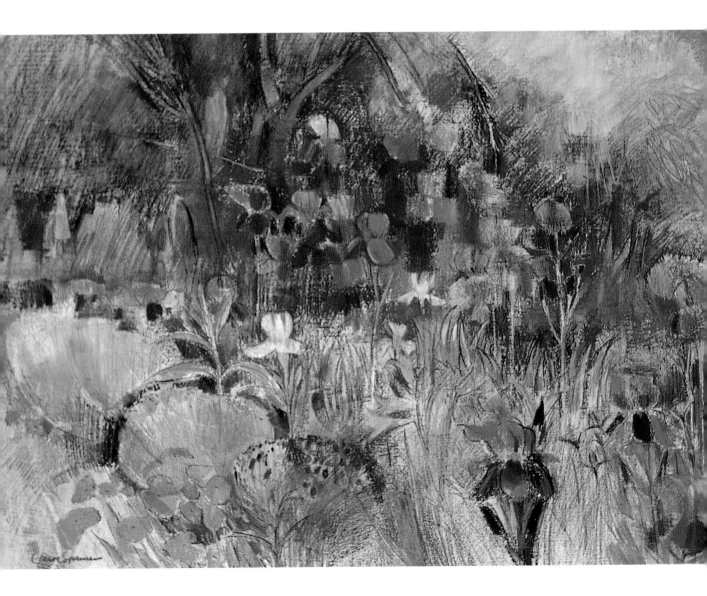

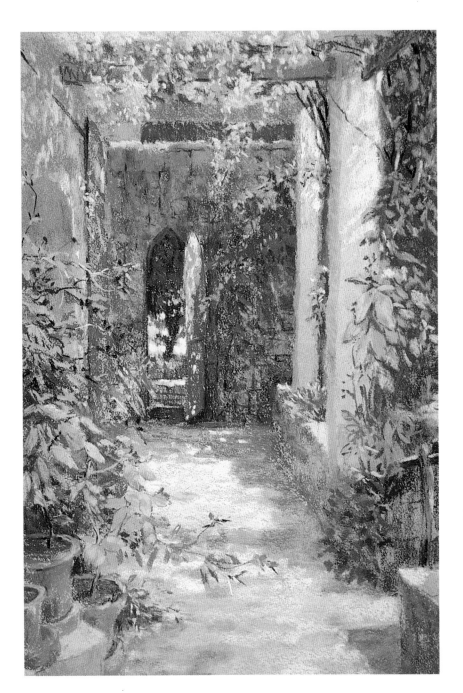

Secret Doorway,
50 x 34 cm
(19¾ x 13½ in)

If you can cope with all these inconveniences, working out-of-doors is very rewarding; direct contact with nature enables you to 'feel' as well as see the scene. Because light conditions are changeable, you will learn to work more quickly and to trust your intuition. The speed with which you have to work outside often plays a major part in the end result. Call it 'happy accidents' if you like, but paintings will often contain passages which pleasantly surprise you when you look at them later. I advise you to begin by working close to home. If you have a garden, this is ideal. Working in a garden avoids the curious onlooker, and will give you confidence to venture further afield.

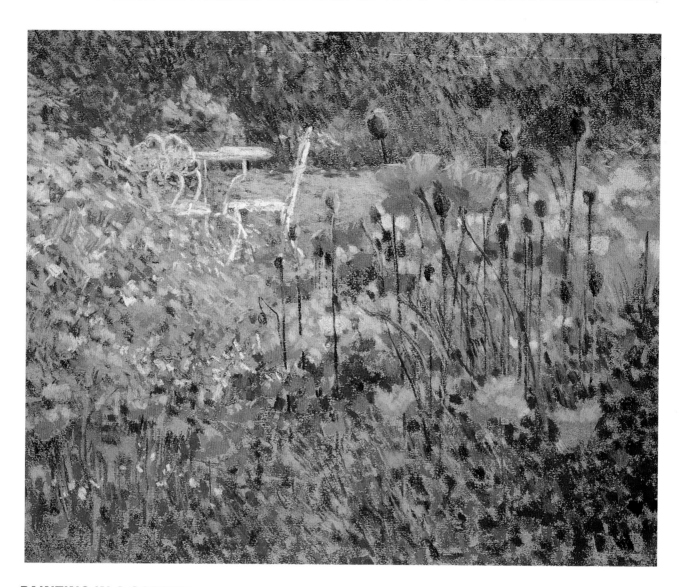

PAINTING IN A GARDEN

Familiar places often seem uninspiring.
However, when you begin to look properly,
using a viewfinder – even the one in your
camera – to select and isolate a small section of
the landscape, things which seemed boringly
familiar suddenly begin to present new and
interesting possibilities. You begin to 'see' with a
painter's eye, noticing things clearly, as if for the
first time. It's most exciting.

Garden paintings offer a wonderful new
challenge. They can, of course, contain elements of
still life: terracotta pots, stone ornaments, garden
tables and chairs, hanging baskets, heaps of logs,
battered old wheelbarrows and watering cans.
Even small, scruffy corners can provide
inspiration. A weathered fence with tumbling ivy;

Poppytime,
30 x 38 cm (11¾ x 15 in).
Only a few of the poppies and
poppy seed-head shapes are
painted. Most of them are
suggested, as are the other
drifts of flowers, by the use
of dots and dashes of pastel.
The 'broken colour' technique
seems to animate this little
garden scene, and adds life
and movement.

discarded flowerpots surrounded by flowering weeds – corners like these can be as exciting to paint as the most lovingly tended flower-bed.

WHERE TO BEGIN

Start by walking around your garden, viewfinder in hand. It is exhilarating to be confronted by vibrant colour and texture, but it is often difficult to select. Having spent a few moments contemplating alternatives through your viewfinder, begin by spending ten minutes or so on some small thumbnail sketches; then launch into the joy of painting, trying to capture the scene as quickly as you can before too many changes take place!

DESIGN

Look back at Chapter 7 to remind yourself of the basics. Try to decide upon a primary focal point – something in your garden which interests and excites you. It may be a small area of flowers, a broken flowerpot, a gnarled tree; allow the painting to revolve around that point. In your thumbnail sketches try to suggest a sense of space, even the limited space of a garden, by establishing a foreground, middle distance and distance.

Look for the light and dark areas of the design by half-closing your eyes to filter out the detail.

Concentrate on broad masses of shape by grouping similar tones together. Don't scatter small areas of varying tone all over the painting – it will just look patchy. Try not to divide your light and dark areas equally. Allow one or other to dominate, or use mainly mid-tones with a small area of either light or dark for dramatic contrast.

Without some time spent on these vital compositional studies, your painting will simply be a rather static record of what you see. Do you remember my warning about shopping lists? Three trees, sixteen tulips, a garden chair and lots of grass?

SIMPLIFYING WHAT YOU SEE

When confronted with a mass of foliage and colour, it is important to try to capture the essentials of what you see, rather than every little detail. Rendering every leaf on every bush would take weeks and would inevitably result in a very stiff over-fussy image.

Given that light conditions change rapidly, so that a fairly quick, spontaneous approach is advisable, we need to simplify what we see. Having said that, we also need to understand what we see in order to be able to simplify purposefully!

Sunlit Patio,
45 x 60 cm (17¾ x 23½ in).
This painting revolves around the focal point of the stone column and tumbling nasturtiums, which are positioned on one of the rectangle's 'official' focal areas. Detail is kept to a minimum in the background foliage, which is treated as broad blended masses with some slight colour and tonal variations. Notice the warm dark area on the right – often depth can be emphasized more by warm, rather than cold, darks.

Summertime Garden

▲ 2

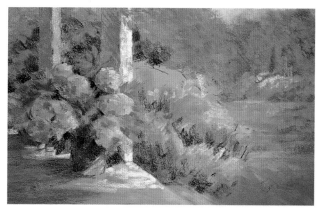

▲ 3

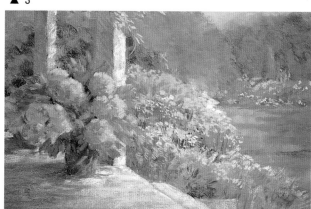

▲ STEP 1

On the smoother side of blue Canson Mi-Teinte paper, I established the main large shapes with charcoal, giving some indication of the light and dark areas of the image by smudging the charcoal with my fingers in the darkest areas. I then fixed the drawing; the pastel would cover the charcoal marks.

STEP 2

I always work across the whole image rather than complete one small area at a time, so I began to 'feel my way around' the painting by roughing in some of the colour, using the sides of the pastels. I kept an eye on light and shade at the same time. As I was planning to build up the pastel in layers over this loose underpainting, I spray-fixed again.

STEP 3

I now began to ask myself questions as I worked. Was there enough variety in my greens? Did the distant greens recede enough or did I need to make them cooler? Were my tones right? Did the grass need to be lighter and more sunlit? To help myself establish the correct range of tones, I brightened the sunlit column, which worked as a 'key' for surrounding tones.

▶ STEP 4

I then felt it was time to create some movement and texture. On the large flower-bed and huge rhododendron heads, I used broken colour in dots and dashes, aiming for general effect and drifts of colour rather than portraits of individual flowers. I suggested the distant flower-bed with smaller marks; the change of scale implied recession. More light, warm yellow-green brightened the lawn and pale pinky-purple glowed subtly warm against the cooler blues.

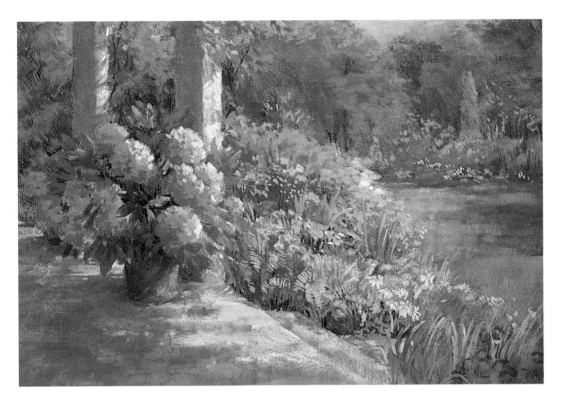

▲ STEP 5

After a light spray-fix, I concentrated on refining the image, softening the tone of the shadows on the terrace and stone columns with a slightly lighter purple-grey. I then worked over the background trees to make more interesting shapes, and painted a few more cool turquoise leaves and daisy heads in the foreground. Finally, I added accents of sunlit yellow leaves and a rich dark brown to the foliage in the flowerpot, which is the main focal point of the picture. I was happy with the colour in the finished painting, as I had wanted a feeling of an English summer garden – not hot, but bright!

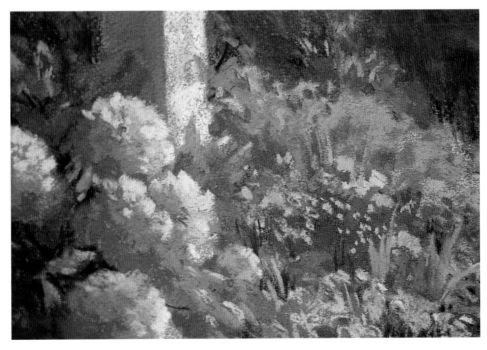

▲ DETAIL

This close-up section shows how dots and dashes of pastel suggest flowers. The rhododendron heads appear full and round because of the gradual movement from light to medium to dark.

COLOURS USED
INCLUDED:
Cream
Pale pink-violet
Yellows – pale and brilliant
Various greens, including light and medium yellow-greens and blue-greens

Blue-violet
Cobalt and ultramarine blues
Burnt sienna – light and dark

COLOUR HARMONY

A natural landscape, such as a woodland scene, often has natural colour harmony. However, a man-made garden is quite a different matter. You might be confronted with a huge variety of colour in a garden scene, and you may need to make a conscious effort to select and organize a colour scheme carefully, leaving out any colours which have no place in the scheme you finally decide upon, even if they are 'there'. An easy way to create colour harmony is to choose a specific colour, and then play down all other colours so that they do not detract from your main choice.

There are lots of ways of using colour effectively – look again at Chapter 5. The important thing is to be prepared to adjust the colours before you to suit your purpose. If you are a complete beginner, please don't be daunted by this idea. Start by looking at some garden paintings and see how the colour has been orchestrated quite deliberately.

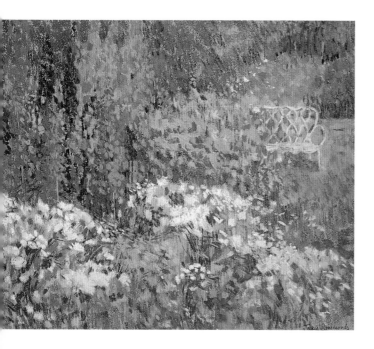

Delphinium Blue,
30 x 38 cm (11¾ x 15 in).
The delphiniums provided the colour key for this image. Blue is everywhere; even the background foliage is created with tiny strokes of blue pastel interwoven with cold blue-greens. Neutral white blends with the blue, and the flash of complementary yellow emphasizes the blue further by contrast.

FOLIAGE

There will be many greens in the scene before you. Look at the variety of tones – the darkest in the shadow areas and the lightest in full sunlight. Colour hue and temperature will also vary. In full sunlight, greens may be warm yellowy-orange; in shadow, they may be cool blue-green. Different types of shrubs and trees are different colours, too. Recognizing these subtle differences in tone and hue will add life and vitality to your work.

Rhythms are created by the way in which plants are formed. Stems twist, leaves curl and bend, branches reach out to the skies, creating angles and patterns not only in the way they grow, but also in the spaces that occur between them. Distinguish between the characteristic shapes of individual plants and shrubs. Beware of simplifying to the point where your shrubs look like so many green cotton wool balls.

TREES

Be careful not to simplify your tree shapes into 'lollipops'. Trees have three-dimensional form and specific shapes in silhouette. Light will describe the form, defining the volume of trunks, branches and clumps of foliage; without attention to this aspect, your trees will look like flat stage scenery! Careful observation of the silhouette will enhance the individual nature of the tree.

Look carefully at tree trunks and branches, particularly their colour. They are seldom simply 'brown'. Garden trees are often close to you, and their trunks very much in evidence. Light will be reflected from all directions onto their cylindrical shape – light from the sun on one side, and reflected light on the other. Close observation will reveal a fascinating array of subtle 'bark' colours – greys, greens, purples and ochres. Shadows on bark can be blue-brown, or sometimes reddish-mauve. Using your pastels with lively, broken marks will also emphasize the illusion of the rough, bumpy surface particular to bark.

Pay attention, too, to the way that the trunks meet the ground. Trees spread out at the base, supported by a solid foundation of roots.

96

Claire Spencer, *Hazels,* 104 x 81 cm (41 x 32 in). The hazel trunks and branches, seen at close quarters, are painted with a rich variety of cool purples, greens and blues in the shadow areas, with warm ochres in sunlit spots. Strong linear outline drawing describes shapes; form is emphasized by the direction of the pastel strokes, which 'wrap around' the trunks.

The Spanish Chair,
56 x 45 cm (22 x 18 in).
A garden scene doesn't
always have to contain
grass and trees. Here, the
heat of the Mediterranean
sun warms the ground, which is painted with broken
pastel strokes of pink,
orange and cream. Cool
shadows vibrate with
strokes of blue and violet,
and in some areas, the warm
grey of the paper is allowed to show slightly through the
pastel strokes in order to
suggest the sun-warmed
ground beneath the shadows.

FLOWERS

You may wish to select certain flowers and make them the focus of attention. Do be aware, however, that you cannot give equal attention to every flower in the garden. If you do, none will be important. Look at Monet's garden paintings – he seldom painted flowers one by one. In his lovely paintings, areas of colour drift across his canvasses; sunlight flickers on flower heads and leaves; shadows dance with muted purples, blue-greys, turquoise. Sometimes it is possible to recognize tall-stemmed irises, or full-bodied roses, but their shapes are suggested rather than painstakingly drawn.

SHADOWS

On sunny days, blue-violet light rays reflect in shadows, and cool shadow areas in your painting will, by contrast, emphasize the warmth of the bright, sunlit areas. Cool light from an overcast sky will also cause shadow, for instance, on the undersides of leaves and bushes. In these light conditions the shadow areas will be warmer. It is a generalization, but it may help to think 'warm light/cool shadow; cool light/warm shadow'.

SKIES

Although skies seldom play an important role in an intimate garden scene, it is useful to notice that the sky can often be seen through the foliage, bringing life and light to otherwise dense areas of greenery. Look at the shapes of these sky areas.

Can Xenet Garden,
45 x 60 cm (17¾ x 23½ in).
The sky peeps through the foliage of the trees, and the top edges of the house and adjoining wall are subtly suggested by the little patches of blue sky.

PROJECT
PAINTING A GARDEN SCENE

Medium
Pastel

Colours
A selection to include the main colours of your subject in light, medium and dark tones; complementary colours; a range of warm and cool greens

Paper
Pastel paper or board

Size
Minimum 20 x 25 cm (8 x 10 in)

Equipment
Sketchbook and pencil
Viewfinder
Charcoal
Fixative
Tissues
Stiff brush for corrections

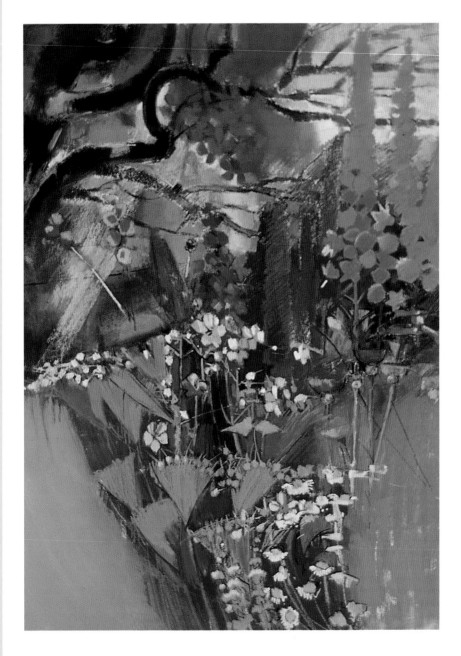

Claire Spencer, *Delphiniums,* 102 x 81 cm (40 x 32 in). Claire flattens form and concentrates on the dynamic qualities of colour, shape and rhythm. The composition thrusts upwards in order to imply nature's vigorous growth, but the eye is held firmly inside the rectangle by the dark twisting tree branches at the top of the image.

For this project, I'd like you to concentrate on two specific aspects of painting a garden scene. The first of these is planning, remembering to make effective use of thumbnail sketches. I suggest that you make a note of the 'checklist' on page 101 in the back of your sketchbook and refer to it as you work. In this way, you will be focusing thoroughly on planning. It isn't possible to plan every aspect of a painting

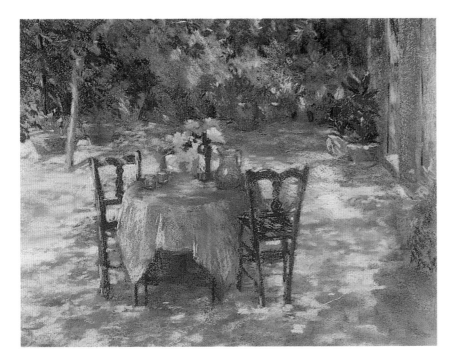

Under the Grapevine,
40 x 55 cm (15¾ x 21¾ in).
This image is a mixture of garden and still life – an interesting challenge! The foliage of the grapevine is treated broadly, leaves bunching into simple shapes. The vine hangs over the table and patio, and this is suggested by the dappled light and shade.

particularly when working out-of-doors, but beginning with a checklist is an excellent discipline. Even the simplest painting will be improved by a certain amount of thinking and planning.

Here is your checklist:

1 Picture notes or title
2 Focal point
3 Direction of light
4 Main shapes and tones
5 Balance of composition

Spend at least ten minutes on your thumbnail sketches. Then decide upon a main colour scheme and think about the colour temperature of the scene.

The second aspect to concentrate on in this project is the simplification of the scene. How you choose to do this, and the techniques you use, are a matter of personal choice. Every artist interprets a scene

in a different way. In general terms, simplify fiddly detail as much as you dare; work broadly, allowing the viewer to do some of the work! Suggest texture – one or two bricks in a wall may be enough to tell the story, for instance. Look back over the chapter for guidance, and perhaps take a long, hard look at the way other artists have tackled foliage, trees, grass and so on if you get into difficulties.

SELF-ASSESSMENT

- *Does your painting have a good range of tones? And echoing shapes? Is it warm or cool?*

- *Did you simplify detail in the darker areas, massing tones and softening edges?*

- *Are your greens varied?*

- *Could you have realized your intention with fewer colours?*

Summer House,
30 x 38 cm
(11¾ x 15 in).
Dots and dashes of pastel suggest banks of flowers and foliage. The pinks and purples of the flowers are complemented by a variety of greens, ranging from very dark to very light.

LANDSCAPES

The landscape, as a subject, simply overflows with potential for painting. Nature provides us with an ever-changing visual feast; the same scene could be painted over and over again, each time differently as the hour, the weather and the seasons alter the face of the landscape. We, as artists, are presented with the opportunity to work towards a worthwhile goal – that of producing paintings which not only capture the essential spirit of a place, but also reflect our feelings towards it.

However, let's learn to walk before we run. Firstly, we need to decide how to interpret what we see. In this chapter, we will look at some of the 'parts of the whole'. It is most important to remember, though, that landscape painting isn't simply a matter of recording individual elements such as trees or clouds, but of recreating an entire scene, taking light and atmosphere into account as well as the elements of design – composition, shape, colour and tone.

▼ *Sunset over Brawn Farm,* 33 x 56 cm (13 x 22 in)

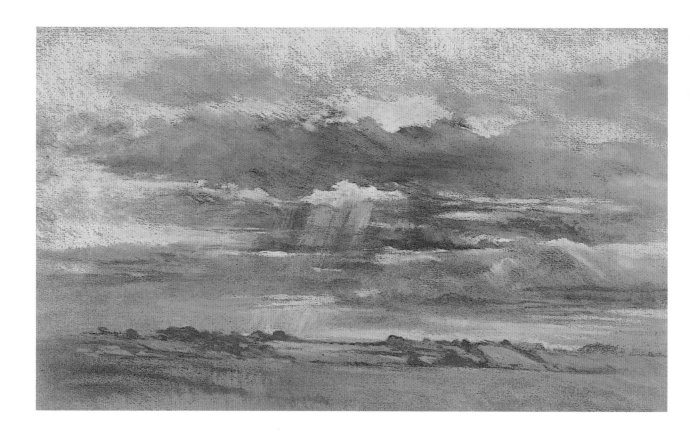

Neil Canning,
Sunflowers,
55 x 75 cm
(21¾ x 29½ in),
mixed media

◀ Clifford Bayly, *Squeaky Beach, Victoria, Australia,* 25 x 35 cm (10 x 13¾ in), oil pastel

▶ Debra Manifold, *Riverside at Wapping,* 52 x 39 cm (20½ x 15¼ in), oil paint and pastel

WHERE TO BEGIN

If you set out determined to find the perfect scene to paint, it is highly unlikely to appear before you – and you will waste much valuable time if you are constantly convinced that it will be better 'around the next corner'. I have found that the best way to choose what to paint in a landscape is to give myself no more than five minutes to select a spot which appeals to me, and then sit quietly for a few minutes longer while I decide why it appealed to me. I often write a short sentence in my sketchbook, or even compose a title for the painting, to remind myself of these first impressions: 'The Bluebell Woods – cool, pale blue-green light floods the scene; the woodland floor is softly carpeted with blues and purples, which seem to reflect up into the tree trunks'. I may not be Shakespeare, but I feel sure that you see what I mean! I then use my viewfinder to help me to choose a suitable composition, and start with a few exploratory thumbnail sketches in my sketchbook.

Don't feel that you always have to find and paint the pretty or the picturesque. Exciting and characterful landscape paintings can be inspired by strange, unusual and decidedly un-pretty corners of town or country. Once you have decided why you like what you see, and having established, through your little exploratory sketches, how you might structure your picture, you are ready to begin.

PRACTICAL TIP

Using a small hand mirror to view work in progress will help you to see your painting afresh. Stand with your back to your picture and study it with the hand mirror. The image will be condensed and reversed, and errors will become apparent.

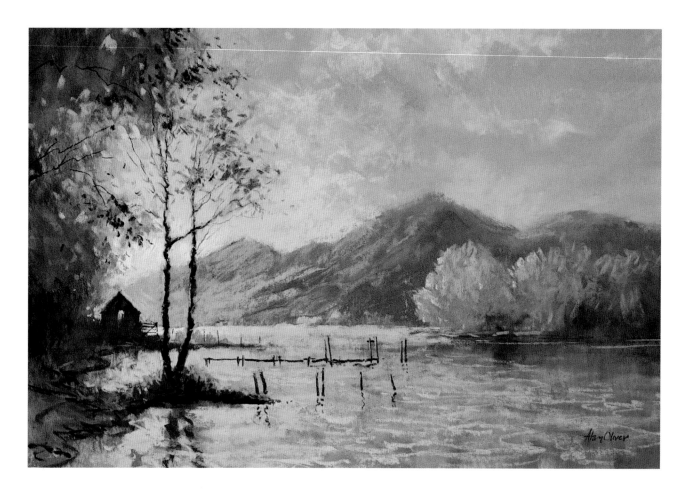

LIGHT IN THE LANDSCAPE

When we paint the landscape, we have to consider the constantly changing effects of light, since light influences everything we see. This may sound rather obvious to you, but it is my experience that students are so concerned with 'how to paint grass' or 'how to paint clouds' that they forget to take the quality of the light into account – and it is so very important.

TIME OF DAY

If you paint in overcast conditions, the light may remain fairly constant and manageable for long periods of time. However, a sunny day will present many problems. You will find that the sun gallops across the sky at a rate of knots – shadows alter in length every time you look up from your work! On a day like this, you cannot possibly hope to start a painting in the morning and continue it all day.

When you begin, always make a note of the time of day and the position of the sun, and

Alan Oliver,
Derwentwater,
38 x 51 cm
(15 x 20 in).
Light from the sky,
reflecting on the
surface of the
water, is
accentuated by
the very dark
tones of the trees,
hut and posts,
which are back-lit
with touches of
brilliant yellow.

indicate shadow areas on your paper from the outset. Try to work as quickly as you can; three hours is probably as long as you can safely hope to paint before the position of the sun changes the shadows drastically. It is best to return to an uncompleted picture at the same time on another day, or perhaps work from sketches or photographic reference to complete the image.

I always recommend to students on a day outing that they attempt a 'morning painting' and an 'afternoon painting'! If this sounds rather ambitious to you, do remember that you do not need to work on a large scale. Small and simple can be just as effective as large and dramatic.

THE COLOUR OF LIGHT

Try to assess the colour and temperature of the light before you begin to paint. The light will be affected not only by the time of day, but also by the season (in some countries) and by the weather. For instance, at dawn, a scene is often bathed in a cool, pink light; in the evening, a warm orange-yellow glow suffuses the atmosphere. Fog and mist will soften colours and reduce contrasts; heavy,

threatening storm clouds paint both sky and landscape in close tones of purple and blue.

In time and with experience, you will learn to exaggerate and manipulate the colour of the light in order to influence the mood and atmosphere of your paintings. You can sharpen your powers of observation by mentally assessing the colour and effects of light as you go about your daily routines. Gradually, this will filter through into your painting.

A SENSE OF PLACE

If you have the opportunity to travel to another country to paint, try to assess the special quality of the light particular to the place. I discovered that in Greece the light is clear and intense; shadows are sharply defined, rich and deep in colour. In Morocco, the light seemed to be affected by the dust in the air and the fiery red colour of the earth and buildings. In Bali, the humidity and the lushness of the tropical foliage seemed to suffuse the entire atmosphere with rich, verdant greens.

Ricefields, Bali,
45 x 60 cm
(17¾ x 23½ in)

SKIES AND CLOUDS

Even if the sky occupies only a small area of a painting, it tends to set the mood. If the sky is light and bright, the scene will be so too; heavy, overcast skies will subdue contrasts and soften colours, and the atmosphere will be drastically different.

Skies and clouds are space, air and vapour. There is always a luminous quality to the sky, which a photograph will seldom convey. Light is everywhere; clouds are fleeting, changing shape rapidly. Capturing these elusive qualities isn't always easy, but it is rewarding.

CLOUD AND SKY PERSPECTIVE

Imagine that the sky is a huge, shallow, upturned basin, poised above your head. The strongest colour and the largest cloud shapes will be immediately above your head, which is the closest point to you. The edge of the basin is the farthest point away from you (the horizon), and here the sky will be paler in colour, and the clouds smallest, with indistinct edges and less tonal contrast.

EXERCISE

Since clouds change shape rapidly, it is certainly tempting to 'freeze' them with a camera and then work from photographs. However, working from nature is the best way to build a knowledge and understanding of cloud structure, colour, tone, light and atmosphere.

Nothing can replace this experience, which will prove invaluable when you come to work indoors from photographic reference, sketches or memory. Do as many sky studies as you can, as often as you can.

David Mynett,
Clouds and Light,
30 x 45 cm (11¾ x 17¾ in).
Soft creams and greys are used to splendid effect in this cloudscape. Sunlight caresses a few cloud edges, but they are quite subtly defined. The artist builds up cloud shapes by blending his pastel strokes with a tissue and fingers, and gradually he overpaints in places, until he is finally satisfied with tone and form. Because there are no really crisp edges, his clouds are softly vaporous.

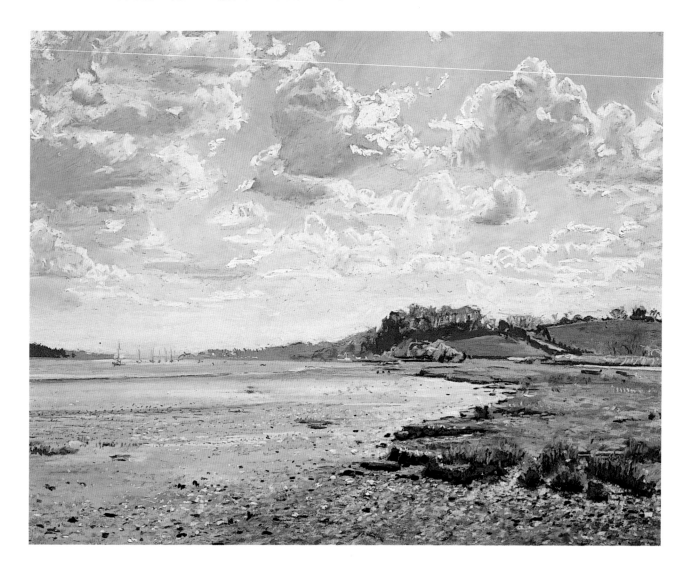

COLOUR

If you have always thought that clouds are white or grey, and skies are blue, do look again, and at different times of day too. At midday, there may well be a great deal of white in the clouds, and the sky may be ultramarine above your head, softening to a pale, luminous turquoise. At the end of the same day, however, the clouds and sky will change to warm pinks and violets. Sunlight on heaps of clouds can turn them pale golden yellow; shadow areas may be pearly greys and purples. Heavy, rain-sodden clouds will be different again in colour – dense, deep blue-purples and purple-brown.

Margaret Glass,
Freston Foreshore,
43 x 56 cm (17 x 22 in).
Always check the direction of the light. Looking into the sun, clouds will be back-lit, with bright edges, and will also appear to be warmly lit from within as the sun shines through them. Light from the left or right will make clouds appear three-dimensional, with appropriate shadows to one side and below.

PAINTING THE SKY

In order to keep an airy feeling to the sky and clouds, it is best to work spontaneously and quickly, trying not to change your picture constantly to capture changes in cloud shapes. Simplify what you see, looking for the main shapes and blocking them in quickly. Half-close your eyes to assess tones better. Harsh tonal contrasts will make your clouds appear solid and wooden, as will too many hard edges; soften edges with a finger or torchon. Look carefully at cloud structure. Clouds are not flat shapes, like stage scenery; they have three-dimensional form, revealed by the way the light falls on them. Decide on colour temperature – is it a warm or cold sky?

Geoff Marsters,
Stour Valley,
49 x 67 cm (19¼ x 26¼ in).
It is easy to forget, when we are concentrating so hard on painting individual parts of the landscape, that each area of a painting must relate to the whole. The sky is simply a shape and colour area which must not be isolated from all the other shapes and colours on your paper. You can 'tie' your sky to the landscape, as this artist has, if you remember to repeat shapes, lines and colours throughout your painting, creating a sense of unity.

Light, Clouds and Rain

▲ 2

▲ 1

STEP 1

First I made a very quick tonal study with charcoal and white pastel on grey paper. My sketch measured 20.5 x 29 cm (8 x 11½ in).

STEP 2

I began to work very freely on the smooth side of a sheet of pearl grey Canson pastel paper, scribbling pastel colours right across the paper using a variety of colours. As I wanted to keep the image soft and loose for a while, I deliberately avoided beginning with a line drawing. On the left-hand side of the picture, you can see where I started to blend the scribbled marks with a tissue. This softened and blurred the colours beautifully, creating a subtle underpainting.

STEP 3

Using the sides of my pastels, I worked over the blended layer, gently starting to develop the sky and clouds. I used dark purple for the undersides of the clouds, and suggested the tree lines with the same colour. To help link sky and land, I stroked a lighter yellowy green over the land and used a little of the same green in the 'body' of the clouds.

STEP 4

I then defined the landscape more positively, using darker colour for the closer tree-line. I applied yet more pastel to the sky, but instead of blending with a tissue, which removes pastel, I softened edges with a finger to blend and intensify the colour.

▲ 3

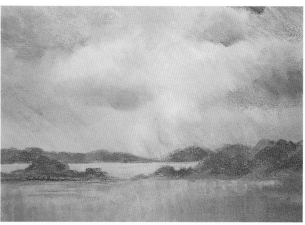

▲ 4

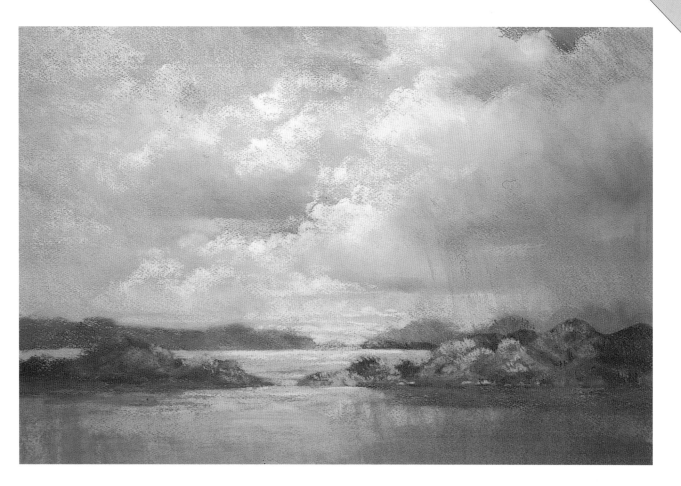

▲ STEP 5

Gradually, I worked towards a resolution of the image, lightening the sky in the top left-hand corner by layering on some paler blue, and suggesting rain by carefully dragging colour down with a tissue from the purple base of the cloud. I used various different greens in the nearest tree-line. By illuminating the topmost edges of the clouds with my lightest creams and sunlit pale yellow, I drew the viewer's eye more positively to this subtle focal area. Finally, I used the same light colours on the middle-distance landscape and on the tops of the trees to show how the landscape absorbs light from the sky.

COLOURS USED INCLUDED:
Cream
Pale pink-violet
Warm and cool greys
Blue-violets — light, medium and dark
Grey green
Ultramarine blue — light
Dark warm green

Yellow ochre — pale
Burnt sienna — light and dark

◄ DETAIL

If you study this detail carefully, you will see that there are some 'edges', but they are deliberately kept soft and vaporous. I used the sides of the pastels, layering the colour with a light touch over previously blended colours. The lightest colours were then pressed more firmly into the paper.

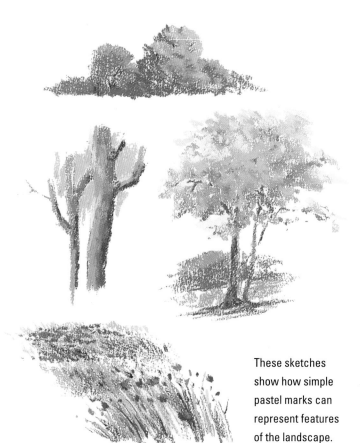

These sketches show how simple pastel marks can represent features of the landscape.

LANDSCAPE FEATURES

The landscape is, broadly speaking, 'clothed' with trees, foliage, hedges and sometimes water, depending on whether your subject is an area of woodland, a view of mountains and hills, or flat pasture. Given the enormous diversity of shapes, textures and colours in the landscape, coupled with the fact that light and weather conditions alter constantly, it is almost impossible to offer anything more than some basic generalizations about painting landscape features. I can give you a few pointers about what to look for, but I ask you, again, to remember that nothing replaces direct observation and analysis.

TREES

We have already discussed trees in Chapter 11 and considered the importance of studying their structure and individual character. However, in a garden setting, it is unlikely that you will be able to see more than part of a tree, whereas in a landscape view, trees may not only appear large

Diana Armfield,
Aspens along the Path in the Rockies,
24.5 x 27 cm (9¾ x 10¾ in).
Notice how the foliage of the more distant trees on the right is seen as one simple shape, the sky carving out an interesting silhouette. Tiny, subtle touches of warm pink on the foreground trees, and gold in the grasses, are offset against a colour harmony of cool blues and greens in this sensitively painted image.

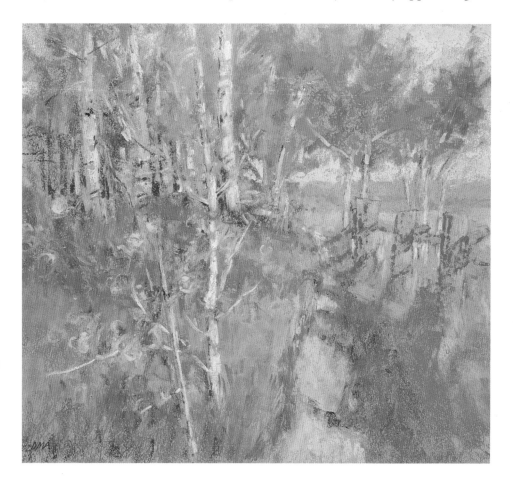

in the foreground, but are silhouetted in the middle and far distance. Seen from a distance, a tree silhouette is more apparent and needs careful observation. More often than not, however, trees will be grouped together, and then they need to be considered as one overall shape with perhaps a suggestion of individual trees indicated subtly where the light strikes them.

As trees recede into the distance, their colours and tones become simple and more muted. Tree trunks, which at close quarters have a myriad of tones, can be simplified into one simple tone.

Last, but certainly not least – your trees will look wrong if their proportions are wrong, so do measure the relationship of height to width, and the distance from the bottom of the trunk to the lower branches. The more you check, t he better.

FOREGROUND AREAS

The foreground is the area which seems to cause students the most problems, probably because of the temptation to include too much detail. Insensitive handling of foreground detail will detract from the rest of the painting, ruining any illusion of depth. Beware of the dreaded 'fringe' at the bottom of your painting – a row of blades of grass, standing to attention like soldiers! Most landscape paintings have a foreground, middle distance, distance and sky, and all four areas need to be harmoniously linked in shape, colour and tone.

In general terms, recession will be emphasized if your marks diminish in size as objects and areas move back in space. Try to keep foreground textures fairly simple. Look for shape patterns and rhythms to lead the eye back into the middle distance; echoing shapes and lines will link one part of the painting with another. Look carefully at colour and tone values, and adjust the colours and tones of the foreground to ensure harmony with the rest of the image. If your painting is largely foreground, make sure that there is plenty of variety in tone and colour to prevent monotony.

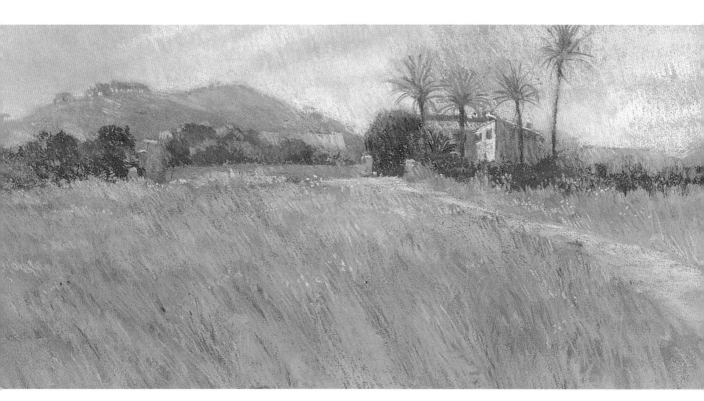

September, Can Xenet,
28 x 58 cm (11 x 23 in)

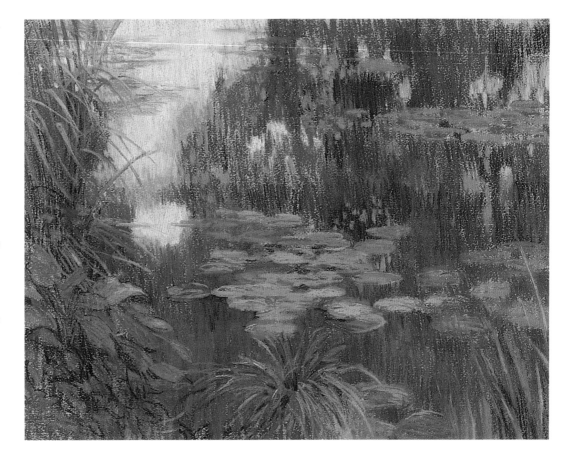

Water Reflections,
45 x 60 cm
(17¾ x 23½ in).
Vertical strokes of
soft pastel were
used for the
reflections of
clouds, sky, tree
and foliage.
Horizontal marks
were then used
for the waterlilies,
and this change of
direction in the
marks helps to
explain the
horizontal plane of
the water's
surface.

WATER IN THE LANDSCAPE

Areas of water in the landscape – rivers and
streams, lakes and ponds, even puddles – provide
fascinating but complex subject matter. You will
find yourself painting not so much water itself,
which is usually transparent, but surface reflections
and underwater depths.

Still water

In still water, reflections are mirror-images with
slight colour and tonal differences; skies are less
bright, colours are slightly muted, darks are less
intense. Also, as you look down into water, colours
and tones close to you will be darker than those
further away. Half-close your eyes to simplify the
shapes of reflections, and check their proportions.
You do not always see a complete reflection of an
object, unless it is right at the water's edge. The
reflection is in direct relation to the object's
distance from the water.

Shadows on water

Shadows cast by overhanging trees, or clouds, will
penetrate clear water to be seen on the bottom,
particularly in shallow water. The important thing
to notice is that edges of shadows will be very soft
and indistinct. When the water is muddy, shadows
sit on the surface – again, with soft edges.

EXERCISES

1 Working at an indoor swimming pool is an ideal way to
concentrate on moving water without the confusion of sky
reflections. The lane lines on the bottom of the pool will, as
they break up, give you clues to help you assess the
shapes created by the water. Use soft pencils, or perhaps
pastel pencils.

2 Another good way of studying moving water is to allow
a garden hose to play a stream of water into a large bowl
or container. Watch the fall of the water, and look at the
way it affects the surface as it hits it. Simplify the
shapes you can see. Use white and black pastels on
mid-toned paper.

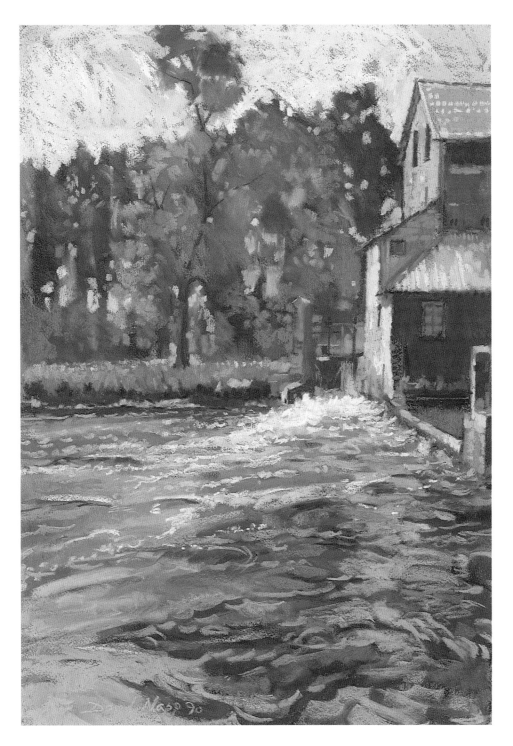

David Napp,
The Old Mill, Normandy,
52 x 35 cm (20½ x 13¾ in).
Churning, frothy water is ably depicted by this artist. The warm green and pink reflections of trees and mill are broken up into abstract shapes, while the agitated surface of the water sparkles white and blue. Bold gestural marks animate the scene and emphasize movement.

Moving water

A water surface broken by eddies and ripples will challenge your powers of observation, as you will be confronted by ever-changing patterns and textures, highlights and shadows. Practise finding ways of simplifying and varying the shapes you see. Bear in mind that reflections, and the spaces between them, diminish in size as they move away from you.

PRACTICAL TIP

When you are faced with reflections of sun and sky sparkling on water, be careful not to use too many white blobs! Overdo it, and your painting will look as though it has a nasty disease!

SNOW

Snow throws a white blanket across the landscape, transforming our world completely. It is challenging and marvellous to paint, so although it is an aspect of 'weather' rather than a particular landscape feature, I felt it was worth a special mention.

COLOUR IN THE SNOW

A snowflake may well be white, but white alone will fail to capture the magical feel of a snowy scene. Light is the key. Snow is basically a body of frozen water droplets, and it has a reflective quality. It will reflect not only sunlight, but light from the sky whatever the weather conditions.

On sunny days when the sky is blue, highlights will be dazzlingly light – not only white, but also high-key tones of lemon, pink and cream. Shadows will be blue, blue-violet, purple-grey, depending on the strength of the sunlight and the time of day. At the end of a day, highlights turn a softer pinky-gold. On overcast days, the land will sometimes appear lighter than the sky; the weak

Alan Oliver, *Frosty Morning,* 25 x 38 cm (10 x 15 in). Sunlit warm ochres and browns contrast with the icy blues and purples in this snow scene. The artist has used a wide range of lively gestural marks, together with softer, subtly blended areas.

winter sun filtering through thick cloud may turn the sky yellow, and the snow will reflect this colour with no strong shadows or bright highlights. Any buildings and trees in the landscape will be dark and dramatic – remember that the mood of the painting can be manipulated by considering and emphasizing all these colour elements.

Sunlight bouncing off snow-covered surfaces often causes light to flood the scene – tree trunks, for instance, sometimes seem to glow with iridescent greens and ochres. By contrast, severe frost conditions will totally subdue all colours and tones in the landscape, and close harmonies of palest blue, green and violet will be needed to evoke the chilly atmosphere.

Snowdrift,
45 x 60 cm (17¾ x 23½ in).
Only the smallest touches of white are used in this pastel, which relies for its impact on the blues and violets in the shadow areas. It isn't necessary to use white to say 'snow'! The tree trunks glow with a gentle, almost iridescent green as light reflects up onto their surfaces. Touches of warm rusts and deep red-browns emphasize the cold of the blues and blue-purples.

These photographs and sketches were used to create *Bluebell Woods* opposite. I never copy a photograph directly – this would lead to a very stiff result. I draw freely from my sketches and photos, trying to capture the essence of the scene. I eliminate superfluous detail, simplifying as much as I can. I may select certain elements of the landscape from one photograph, lighting and mood from another. I adjust colour and tones to suit my purpose.

A WORD ON PHOTOGRAPHY

I'm sure that there are many among you who suspect that using a camera is a form of cheating. Well, great artists like Degas, Monet, Corot and Sickert all used photographs as reference material, and I'm sure they didn't feel it was cheating! They knew how to use their photographs effectively and creatively – they didn't mindlessly copy.

It is important to realize that the human eye and the camera's eye are very different. With the naked eye, we see distant objects far larger than they will appear on a photograph. Photographs can give a misleading impression of colour and tone, as sunlit areas and skies are often bleached out. Also, they seldom convey a proper sense of aerial perspective – distant trees, for instance, are often too dark and heavy. Tones jump from very dark to very light; there are few of the subtle mid-tones, which are obvious to the eye. The camera also flattens form, particularly in

dark areas. So you can see that the camera has many limitations, and certainly, if you use a camera exclusively, without taking time to look hard, you are likely to be so disappointed with the results that you are unlikely to paint from your photographs at all!

By all means use a camera, but use it selectively, as a tool, ideally in conjunction with

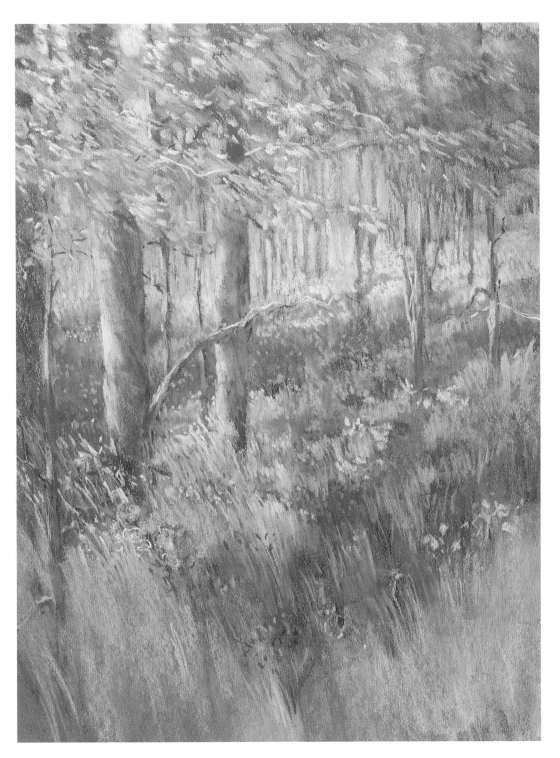

Bluebell Woods,
60 x 45 cm
(23½ x 17¾ in).
This painting was
created in the
studio from
sketches,
photographs
and memory.

your sketchbook. Take practical information photographs to the right and left of your subject, and some close-ups for detail. On wet and cold winter days, working from photographic reference is a useful way to help you to gain confidence, and solve problems. When the weather improves, you'll be able to tackle the landscape with renewed enthusiasm.

EXERCISE

Take a black-and-white photocopy of a colour photograph and then work from it, interpreting the colour creatively. This is an exciting way to develop your personal ideas about colour.

PROJECT
CREATING A SENSE OF SPACE

Medium
Pastel

Colours
A selection of colours in light, medium and dark tones, to include blue-greys and grey-violets; warm and cool greens; earth colours; blues

Paper
Pastel paper or board

Size
20 x 25 cm (8 x 10 in) minimum

Equipment
Sketchbook and pencil
Charcoal
Tissues
Fixative
Small hand mirror
Stiff brush for corrections
Viewfinder

One of the main challenges of landscape painting is to be able to create space and depth. The images on these pages demonstrate what I mean.

Hopefully, you will be able to work directly from your subject, but if this is impossible for you, then as a last resort you can work from a good photograph. You should work creatively from your photograph, adjusting colours and tones to emphasize space. Feel free to leave things out, or add things in, to suit your purpose. Compositional sketches will help in this respect – you may find that more sky and less landscape will create a greater effect of distance; or that lines of trees, paths or ploughed fields can be used purposefully to lead the eye into the picture and the distance.

▲ *Estuary Reeds,*
45 x 66 cm (17¾ x 26 in).
In this simple, uncluttered image, the eye is encouraged to move back in space gently, not only by the obvious change of scale in the reeds, but also by the subtle zigzag shapes of the 'islands' in the water. Notice how effectively colour knits the sky to the landscape: the same icy grey-blues are used for both sky and water.

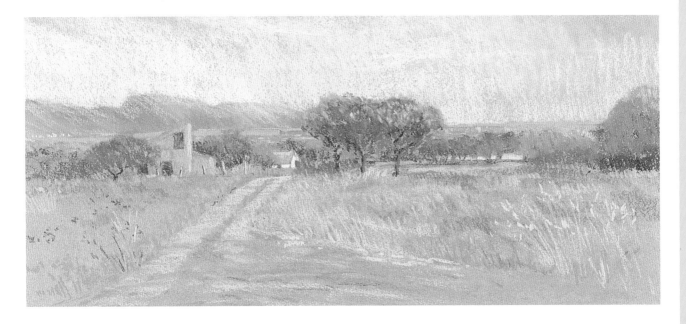

When you have completed your painting you might like to extend the project further. This time, instead of focusing solely on depth and space, change and emphasize the mood and atmosphere of the painting. You can do this quite simply by changing the time of day, the weather or the season. It will be necessary to adjust your 'palette' for this new painting. Think about it carefully; select the pastels you think you will need

and test the colours on the edge of your support. Make sure your colour is harmonious, and remember that you do not always need a huge selection; sometimes fewer colours may strengthen the expressiveness of the image.

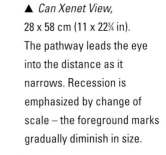

▲ *Can Xenet View,* 28 x 58 cm (11 x 22¾ in). The pathway leads the eye into the distance as it narrows. Recession is emphasized by change of scale – the foreground marks gradually diminish in size.

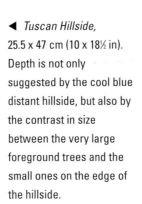

◀ *Tuscan Hillside,* 25.5 x 47 cm (10 x 18½ in). Depth is not only suggested by the cool blue distant hillside, but also by the contrast in size between the very large foreground trees and the small ones on the edge of the hillside.

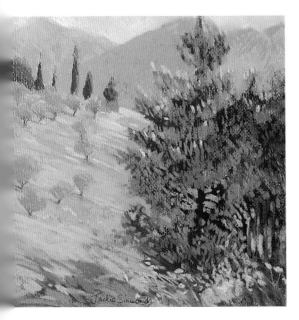

SELF-ASSESSMENT

- *Did you think about aerial perspective to help you emphasize depth?*

- *Did you remember to use change of scale in your marks?*

- *Were you able to link the sky and the land in some way? If so, how? With colour? With shapes?*

- *Do the lines and shapes in the image lead the eye to the focal point?*

SEASCAPES

Sea and sky, rocks, cliffs, beaches, boats – all these are wonderful subjects which rarely fail to inspire, delight and occasionally frustrate the painter! The sea, in particular, presents a great challenge. Most successful sea pictures have been painted by artists who have studied the sea for many years in order to learn how to capture its awesome power and energy, and its ever-changing moods. Waves, foam, breakers and swells will require much patient practice while you familiarize yourself with their movement and shapes.

Beach scenes, which include cliffs, rocks, breakwaters, boats and even people, are excellent subjects to start with. Here, the sea becomes part of the scene and can be treated in a fairly straightforward way.

▼ Alan Oliver, *Cromer Beach*, 28 x 38 cm (11 x 15 in)

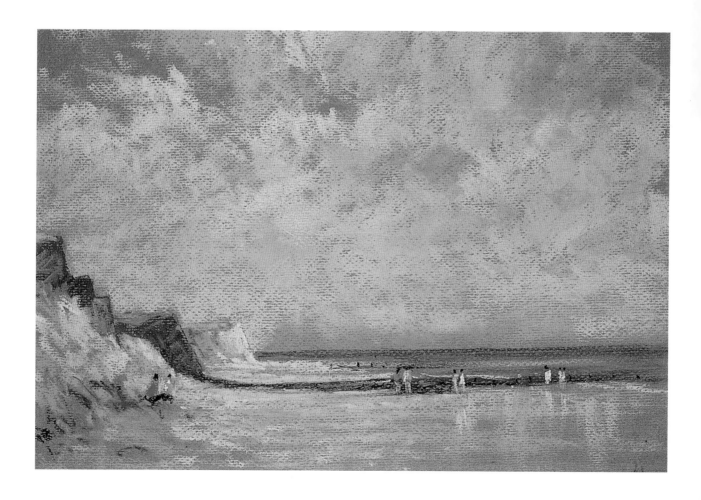

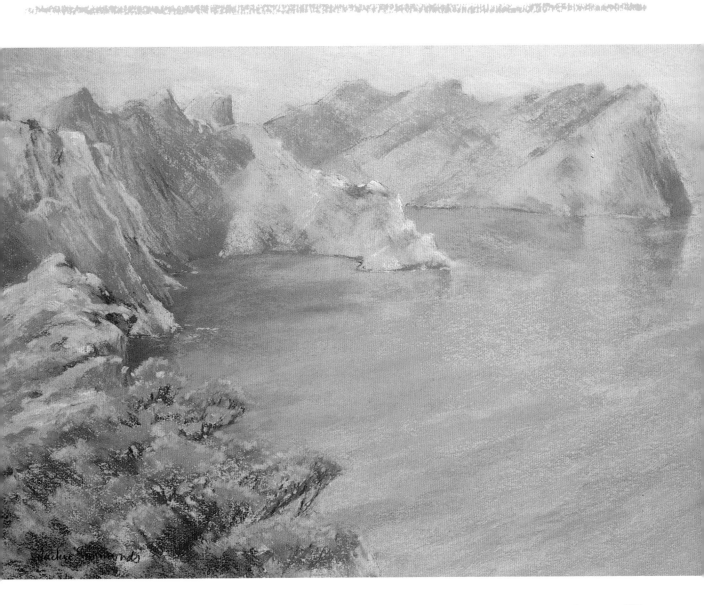

WHAT TO LOOK FOR

The sea, viewed from the beach as a horizontal shape, can present you with compositional difficulties – a panoramic view of the sea can be lovely to look at, but can easily appear deadly boring in a painting! It is important to create a focal point or area. This may be as simple as a translucent highlight at the top of a wave as the light streams through, or water curling and foaming around a rock formation. Observe the horizon carefully. Where sea and sky meet, the atmosphere is often hazy, and too hard an edge will look unnatural. Be aware of the interaction between sea and sky. A light sky will make the water look light; a dark sky will reflect down into the ocean, and it, too, will darken quite considerably.

Formentor Cliffs,
45 x 60 cm
(17 ¾ x 23 ½ in)

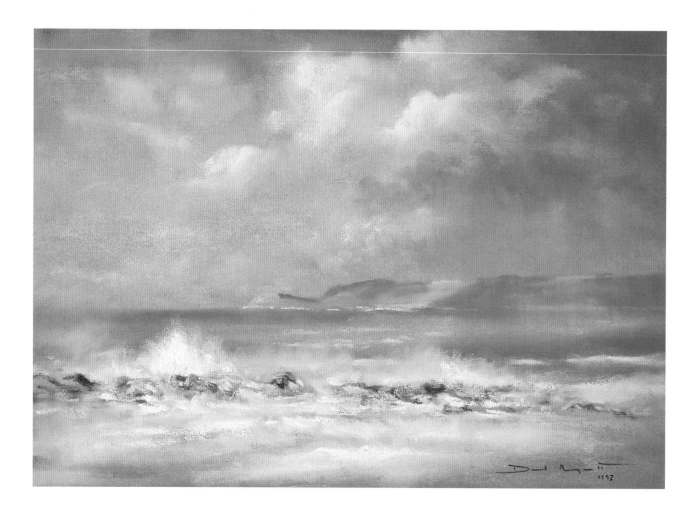

Study tonal changes carefully – cloud shadows and changing water depth can create patterns on the water which help to break up a large horizontal shape, giving a sense of recession and movement. Waves and breakers have specific areas of dark and light. Usually, there will be a deep shadow under the crest of a wave, and the light will catch the top, making the thinnest part of the wave light and translucent. Spend some time just watching, and then sketch, recording as much information as you can each time a wave breaks in front of you. Gradually, you can add more details with each subsequent wave, building onto your sketch.

David Mynett,
Incoming Tide,
Cornwall,
30 x 46 cm
(11¾ x 18 in)

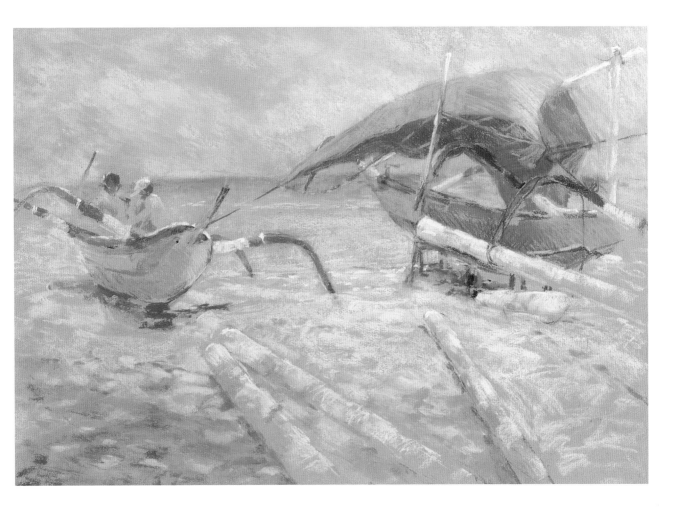

THE BEACH

Notice how the colours and tones of the sand change as waves recede; wet sand will initially be light and reflective, and will darken slowly as the water seeps away (see my picture, *Dorset Shoreline*, on page 131). Simplify pebbly beaches – 'suggestion' works best. Look for simple, large changes of tone to establish a sense of recession. There is a great temptation to use a pointillist technique for pebbles, and it can be most effective, provided you bear in mind that your marks must diminish in size as the eye moves towards the distance.

Outriggers, Bali,
45 x 60 cm
(17¾ x 23½ in)

CLIFFS

Study the structure of the cliff face and its formation carefully. It is best to treat cliffs as simple shapes, adding just enough detail to describe their character. 'Less is more' is an excellent motto to remember. Bear aerial perspective in mind; look for overlapping shapes, and reduce tones as shapes move back in space.

ROCKS

Rocks tend to be solid, bulky objects with three-dimensional form. The changes of plane may be quite complicated, but if you squint, the light will help to describe their main shapes for you. Varying the direction of your pastel strokes will also emphasize changes of plane. Once you have established the main shapes, with simplified tones and colours, you can then add a little detail to describe fissures and texture.

Norman Battershill, *Incoming Tide*, 30 x 45 cm (11¾ x 17¾ in). Brown pastel paper was chosen for this stunning image, the warm colour and dark tone suggesting depths in the water and the base colour of the rocks. Contrasting cool blues, greens and greys are used for the surging water while the brilliant light on the surface, and the tumbling foam, are suggested with strokes and crumbly pastel marks of palest violet, ice blue and white.

BOATS

Boats aren't easy to draw, particularly for those of us who seldom see a boat other than on the occasional holiday or day outing. Boats seldom pose properly. They tilt at angles on a beach, or they bob about disconcertingly when they are afloat! Their shapes are complicated by the sweeping curves from front to back, and the bulge from top to bottom of the hull.

However, I have no doubt there are many of you determined to accept the challenge and include boats in your paintings. If so, you must be prepared to do plenty of sketching to familiarize yourself with their shapes and structure. Boats vary in shape and size, and if they are poorly drawn, they will spoil the rest of your painting. Concentrate hard on proportions, comparing width to length; if there is a mast, carefully check its height and compare it with the length of the boat.

▲ Drawing as many boats as possible, as often as you can, will improve your confidence in tackling their difficult shapes.

▶ Margaret Glass,
Low Tide, Woodbridge,
38 x 56 cm (15 x 22 in),
glasspaper.
We are led into the picture by the lines in the waterlogged sands. These direct the eye towards the pools of water, and the boats, which have been painted with a directness and economy that can only come from a thorough understanding of structure and form. Margaret uses glasspaper as her support; its abrasive surface 'grabs' the pastel and each mark is rich and buttery, looking almost like thick impasto oil paint.

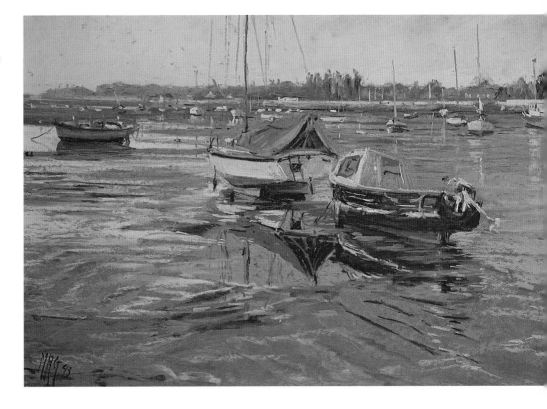

PROJECT
SEA AND SHORE PAINTING

Medium
Graphite and/or
coloured pencils
Pastels

Paper
Pastel paper or board

Size
Minimum 20 x 25 cm (8 x 10 in)

Equipment
Sketchbook
Viewfinder
Camera
Charcoal
Fixative

Unless you are lucky enough to live near the coast, you are unlikely to have tackled many 'seaside' paintings, nor will you have a proper store of visual memories to help you to work adequately from photographs. Given the difficulties you will encounter – the sea heaves and shifts, beaches are strange colours, jetties and rocks are strange shapes – I strongly feel that you need to have first-hand experience of this type of subject. Once you have looked, sketched, and absorbed, you will then be vastly better equipped to paint effectively, either on the spot or later from sketches and photographs.

I'd like you to plan a trip to the coast and make a 'working sketchbook of sea and shore'. Do as many small drawings as you can in pencil, and perhaps coloured pencil too, to familiarize yourself with the scene. Make colour notes, not just of the objects you see, but also about the colour and temperature of the light. Observe how the sky affects the colour of the sea. You will be using your sketches for information, so you will need quick sketches to capture the essence of the scene, and more detailed sketches too. Take photographs to back up your drawings. Before long, you will have a wealth of material, knowledge and memories from which to work. I wish I could come with you!

Next, produce a painting from your reference material. Before you begin to paint, ensure that you are entirely clear about the mood and atmosphere you want to create. You will need to think about how to organize colour, design and technique to reinforce this intention. Then, do your best to produce a lively, fresh painting which captures the feelings you experienced on the spot.

◄ Sheila Goodman,
Studland Beach,
28 x 47 cm (11 x 18½ in),
soft pastel on glasspaper.
The curving shapes of the
sand dunes are offset by the
horizontal sweep of sea and
sky. Sunlight casts cool blue
and blue-purple shadows
across the warm golden
sands. Pastel used on its side
across glasspaper gives a
rough texture, which is used
to excellent effect on the
surface of the sand.

▲ *Dorset Shoreline*,
45 x 60 cm (17¾ x 23½ in).
As water sweeps across sand
and shingle, it is absorbed in
places, darkening the surface
of the sand, while in other
areas water on the surface
reflects light. Side strokes of
pastel emphasize the receding
waters, while the agitated
surface of the sea is created
with small strokes, using the
point of the pastel stick. Light
colours are worked over
darker tones.

▲ Alan Oliver,
Brittany Beach,
28 x 38 cm (11 x 15 in).
Beach scenes are always
enlivened by the addition of
figures. In this image the
figures are very simply
treated; their reflections in the
still water add extra interest.

SELF-ASSESSMENT

- *Did you collect adequate
 information?*

- *If not, how, next time,
 could you improve your
 information-collecting?*

- *Do you find it frustrating
 to work away from the
 subject? If so, don't
 worry — many artists
 prefer to work from life.*

THE HUMAN ELEMENT

Putting people in your pictures immediately adds life, movement and scale to a scene. However, people seldom behave as we'd like them to, positioning themselves in convenient groups and then standing politely still while we draw them! As a result, artists often resort to adding the figures at a later stage, and a certain freshness and liveliness can be lost along the way.

Learning to draw figures convincingly is a worthwhile and fascinating study – they will bring a new dimension to your paintings. In general terms, it is best to depict figures quickly and simply, with patches of colour rather than fiddly detail, and always make sure your figures relate properly in size to their surroundings.

▶ Anthony Eyton, *The Grotto, Lourdes,* 65 x 49 cm (25½ x 19¼ in). The figures are economically stated with sketchy strokes and stabs of pastel, which add life and vitality to the scene. The vertical composition allows the artist to emphasize the cathedral-like atmosphere of the cave, as the towering walls dwarf the figures.

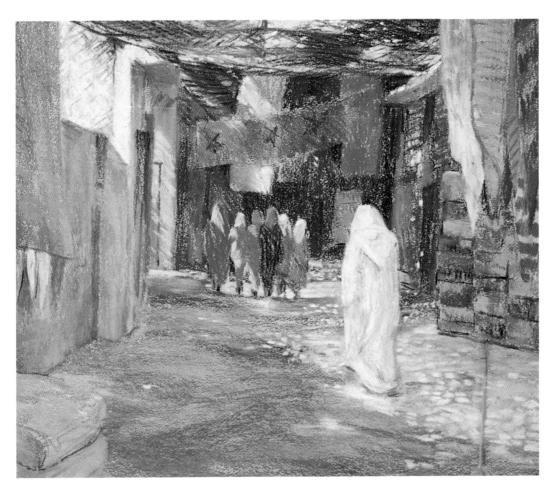

◀ *The Souk,* 40 x 46 cm (15¾ x 18 in). The distant figures were initially treated as one shape. If you look carefully, you will see that two of the blue-robed figures are still painted as one. Pink pastel paper was used to reinforce the atmosphere of warmth.

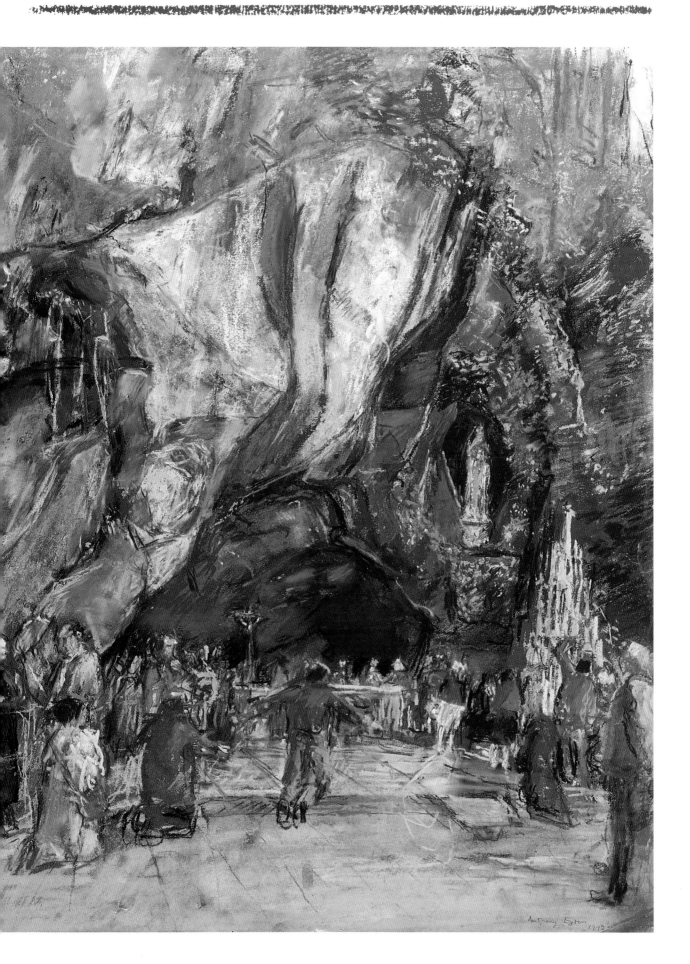

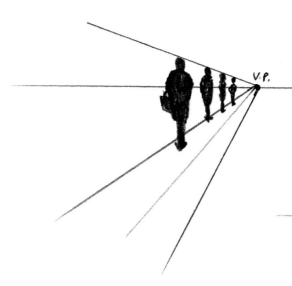

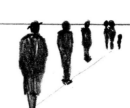

SKETCHING

It is a good idea to get into the habit of carrying a pocket sketchbook around with you, in order to make lots of rapid sketches of figures as often as you can. Try to find figures which may remain in one spot for some time – a fisherman, for instance, or one or two people sitting on a beach or park bench. Work small, keeping your sketches simple and without worrying about details, features, hands or feet. Start with simple angles for shoulders, hips and spine, and then develop the shape of the body. Aim for the correct bulk and stance. If you are brave enough to attempt moving figures, try to ensure that the balance and weight are right. If you draw someone who is doing something repetitive, you will be able to build up the drawing gradually as they return to the same position from time to time. With plenty of practice, you will be surprised how quickly your confidence and skill will develop.

Perspective applies when placing figures in a scene. As the figures move away in space, they appear to reduce in size. Also, if you, the artist, are standing and all the figures are also standing or walking, their heads (allowing for slight variations in actual height) will all be on the same level – your eye-level. If you are sitting to paint, then the heads of the people farthest away in space will be lower that those in the foreground, who may be towering over you. Overlap also helps to position figures in space.

GROUPS

Groups of figures often present an intriguing solid mass, topped with heads at slightly varying heights, with odd elbows and legs. Tackle the main shape first, and eventually add simplified suggestions of colour, together with some highlights, in order to distinguish some of the individual figures.

PRACTICAL TIP

A common error is to make heads too large. Always make the head smaller than you think you should. It is far better to have a head a little too small than too big.

EXERCISES

1 If you are far too nervous to sketch people out-of-doors, begin by working from photographs. Newspaper photographs are useful, or photos of your own family. Aim to fill a sketchbook with small figure sketches.

2 From a series of photographs, build up figure groups, starting with one figure and gradually adding others, until you have a group which forms an interesting shape. If you use charcoal, you will find it easier to simplify forms. Draw one figure over another and then blend lines with your finger. Because you are working from different photographs, the figures may differ in scale, and you will have to make some adjustments. This will help to develop your sense of proportion.

When you have completed several charcoal group sketches, translate the drawing into colour. Keep your pastel marks as simple as possible, aiming for an impression.

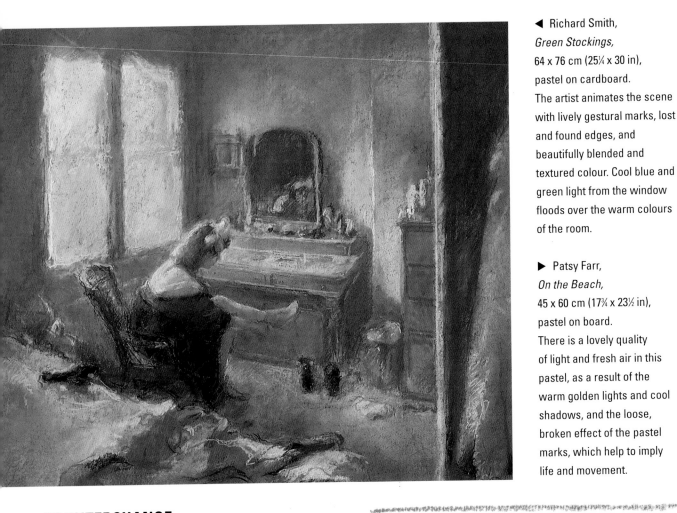

◀ Richard Smith,
Green Stockings,
64 x 76 cm (25¼ x 30 in),
pastel on cardboard.
The artist animates the scene
with lively gestural marks, lost
and found edges, and
beautifully blended and
textured colour. Cool blue and
green light from the window
floods over the warm colours
of the room.

▶ Patsy Farr,
On the Beach,
45 x 60 cm (17¾ x 23½ in),
pastel on board.
There is a lovely quality
of light and fresh air in this
pastel, as a result of the
warm golden lights and cool
shadows, and the loose,
broken effect of the pastel
marks, which help to imply
life and movement.

COUNTERCHANGE

Because the viewer's eye will always be drawn to
figures in a scene, the placing of the figures is
critical – it seldom works to put them in as an
afterthought. If your figures are the focal point of
your image, you can emphasize them with the use
of counterchange: a light figure against a dark
background, together with a dark figure against a
light area.

EXERCISE

When you feel brave enough to venture out with a
sketchbook, a good place to begin is a public library! People
often stand at the shelves for some time, and others will be
sitting, reading. As unobtrusively as you can, make a series of
quick pencil sketches, allowing yourself a few minutes only
for each drawing. When you draw the standing figures, look
specifically to see which leg carries the weight of the body if
the weight isn't evenly balanced, and study the angle of the
head in relation to the body.

Keep your drawings quite small, and add a little
information about the surroundings so that your figures don't
float in space.

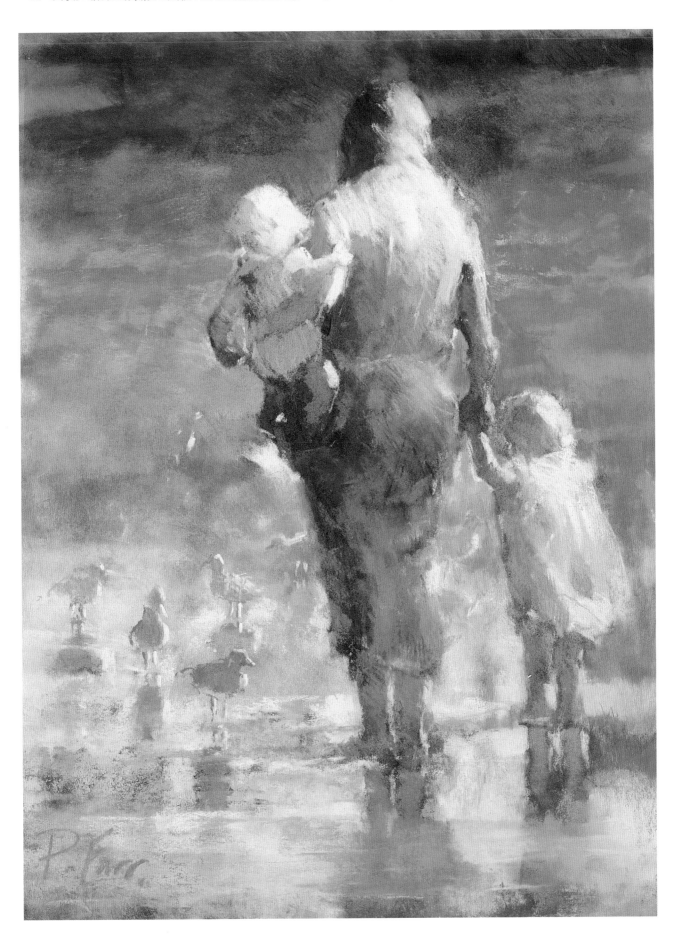

INTO
ABSTRACTION

May I suggest to you that we are all, to a greater or lesser degree, abstract artists... I can almost feel the outrage from some quarters, so what do I mean? Well, my feeling is that all painting is, in fact, abstraction. When we paint in a representational way, we simply make marks – marks which represent what we see.

I firmly believe that the expressiveness of any representational work of art is as much the product of its abstract qualities of colour, texture, line, shape and pattern as of its subject matter. You may never paint an abstract painting as such, but if you are aware of abstract qualities, it will enrich all of your work. I believe that abstract and representational art should be able to draw from each other, rather than be mutually exclusive.

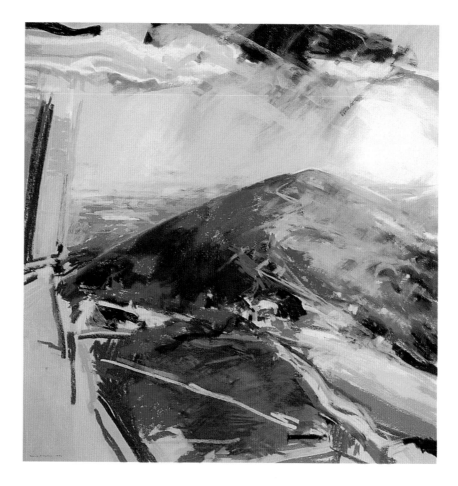

David Prentice,
*Coloured Counties
– An Air that Kills,*
87 x 87 cm
(34¼ x 34¼ in)

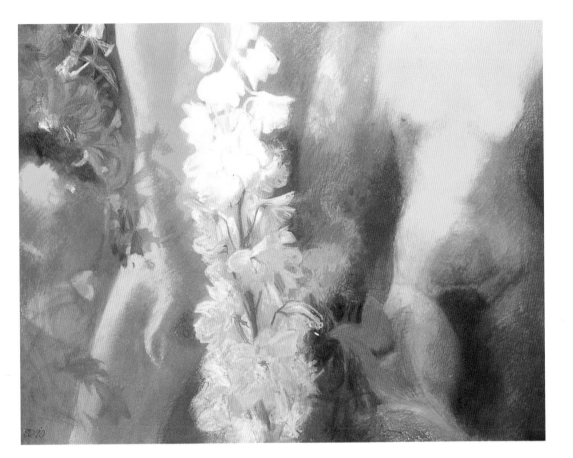

Brian Dunce,
Adam and Eve,
51 x 103 cm
(20 x 40½ in),
oil pastel

WHAT IS ABSTRACTION?

I confess little practical knowledge of abstract painting, but as a student, I was taught that there are two meanings of the word 'abstraction'. According to the first definition, the artist begins with recognizable visual or imaginary forms, and by simplifying, or extracting motifs from them, produces abstract paintings. In the second meaning, the artist begins with the abstract qualities of shape, colour, line and so on, and uses them without reference to recognizable subject matter.

It is easy to understand and appreciate realistic or representational paintings. Abstract paintings are more difficult to evaluate and so present rather more of a challenge. If you have previously been rather dismissive of abstract works, I urge you to look again, and this time use your new-found understanding of the abstract qualities of colour, shape, form, texture, and the rest, to see anew, and appreciate the creativity, beauty, unpredictability and also excitement of abstract paintings.

Richard Plincke,
Con Brio,
33.5 x 52 cm
(13¼ x 20½ in),
oil pastel

FINISHING A PAINTING

Recognizing when a painting is finished is not easy, even for the most accomplished painter. Painting is a continual process of analysis and evaluation, which makes great demands upon your concentration. If you feel you have achieved the broad effects you were looking for, but aren't totally sure if you have finished or not, curb the temptation to fiddle! Leave your work for at least ten minutes – perhaps even overnight. When you return to it, you will see it with fresh eyes. Your energy will have returned, and with it your ability to resolve any problems and add finishing touches.

Don't be too critical of your work, and don't always expect to succeed in every painting. Each painting presents a new challenge and a positive learning experience. Remember the saying: 'From little acorns, large oak trees grow'! Successful work is built on the experience of many failures. The feelings of frustration, as well as exhilaration, are an inevitable part of a worthwhile activity! Store unsuccessful paintings and look at them again later – you may feel inclined to try again. Old paintings are also a useful yardstick against which to measure your progress.

▶ *Woodland Walk,* image 49 x 68 cm (19½ x 26¾ in), framed 74 x 90 cm (29 x 35½ in)

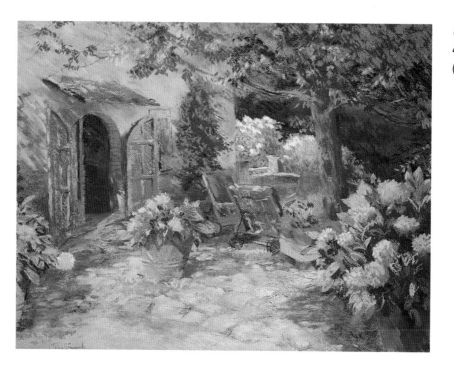

Camaiore Terrace, 45 x 60 cm (17¾ x 23½ in)

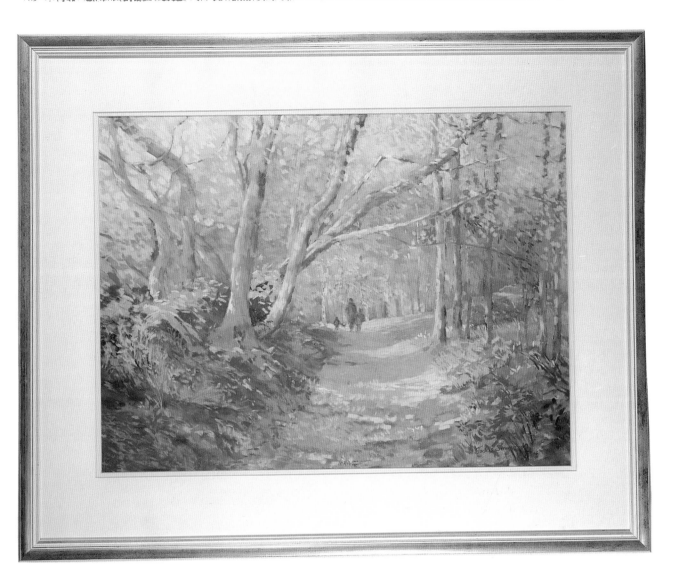

FRAMING

As a complete beginner, I remember thinking that I would never be good enough to frame anything, but I can assure you that there will come a time, and perhaps more quickly than you imagine, when you will be proud enough of a painting to want to frame it. Once your painting is under glass, it will not smudge, it will not fade and it will last for ever, so please do justice to your efforts by framing properly. Poorly framed works look tacky. A well cut mount and good strong frame will enhance your work.

IN CONCLUSION

No book can turn you into an accomplished painter. What it can do is give you starting points from which your own personal approach can develop. I offer you the words of John Ruskin:

'Every increase of noble enthusiasm in your living spirit will be measured by the reflection of its light upon the work of your hands.'

May the light of your enthusiasm for painting never die.

INDEX